D0952536

AMERICAN TREASURES
OF THE
CORCORAN GALLERY
OF ART

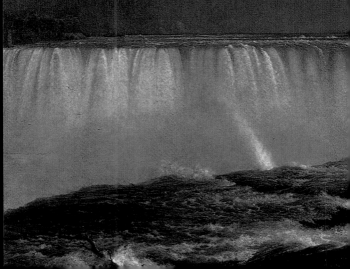

Foreword by David C. Levy
Text by Sarah Cash with Terrie Sultan

A Tiny Folio™
Corcoran Gallery of Art, Washington, D.C.
Abbeville Press Publishers
New York London Paris

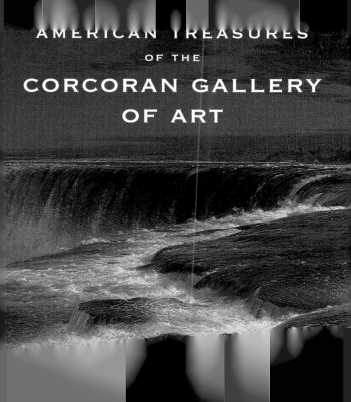

AMERICAN TREASURES

OF THE

CORCORAN GALLERY
OF ART

Front cover: Detail of Mary Cassatt, *Young Girl at a Window,* c. 1883. See page 118.

Back cover: Gene Davis, *Black Popcorn,* 1965. See page 231.

Spine: Hiram Powers, *The Greek Slave,* 1846. See page 62.

Pages 2–3: Detail of Frederic Edwin Church, *Niagara,* 1857. See page 79.

Page 8: The façade of the Corcoran Gallery of Art.

Page 14: Detail of Gilbert Stuart, *George Washington,* c. 1800. See page 30.

Page 40: Detail of Albert Bierstadt, *The Last of the Buffalo,* c. 1889. See page 83.

Page 94: Detail of Mary Cassatt, *The Letter,* 1891. See page 119.

Page 158: Detail of George Bellows, *Forty-two Kids,* 1907. See page 170.

Page 208: Detail of Gene Davis, *Black Popcorn,* 1965. See page 231.

For copyright and Cataloging-in-Publication Data, see page 287.

CONTENTS

FOREWORD

The Corcoran Gallery of Art, Washington's oldest and largest private art museum, is recognized nationally and internationally for its outstanding collection of American paintings, sculpture, works on paper, and photography. The Corcoran has always been a pioneering institution in American art. Its founder, William Wilson Corcoran, was among the first American collectors to seriously appreciate contemporary art of this country, at a time when most of his peers favored European works. His important collection of mainly American paintings and sculpture formed the nucleus of the art museum he founded in 1869. Corcoran's enterprising nature extended to the establishment of a school of art in 1890, carrying out his desire to encourage future generations of artists.

The buildings that have housed the Corcoran Gallery of Art embody a similarly forward-looking spirit. The original edifice—designed by James Renwick and home to the Corcoran from 1874 to 1897—was among the first American buildings designed specifically to house works of art. In 1897 the Gallery moved to the present building, which was designed by Ernest Flagg (with a 1928 addition by Charles Platt). With its classic Beaux-Arts proportions and galleries flooded with natural light, it is recognized as one of the finest museum buildings anywhere.

Over its 130-year history the Corcoran's collection of American art has grown dramatically through purchases and generous gifts. Today, it totals over fourteen thousand objects dating from the sixth century B.C. to the present, at the core of which is a world-renowned collection of nineteenth-century American paintings, sculpture, prints, drawings, and photographs. The collections of eighteenth- and twentieth-century American painting, sculpture, and works on paper are augmented by a highly regarded collection of modern and contemporary photographs and media arts. In keeping with its founder's commitment to the art of his day, the Corcoran continues to build its contemporary collection, notably through purchases made from the Biennial exhibitions of contemporary art, begun in 1907.

The Corcoran is a place where the past, present, and future of the visual arts come to life: the past in the museum's extensive collection of American and European masterworks, the present in its ongoing exhibitions of contemporary art, and the future in the classrooms and studios of its acclaimed art school. I hope that the works of American art reproduced here will entice you to visit the originals in the Corcoran's splendid surroundings.

David C. Levy, President and Director

INTRODUCTION

The Corcoran Gallery of Art was founded in 1869 as an institution "dedicated to art, and used solely for the purpose of encouraging the American genius." It began as the private art collection of William Wilson Corcoran (1798–1888), founding partner in the successful banking firm of Corcoran and Riggs. His original collection, many examples of which are reproduced in this volume, featured American landscape painting, including views by Thomas Cole, Jasper Francis Cropsey, and Thomas Doughty. He also owned a large number of genre scenes, by artists such as Seth Eastman, Eastman Johnson, Frank Blackwell Mayer, and William Tylee Ranney. The collection was rounded out by canvases by Emanuel Leutze and Thomas Sully as well as by Hiram Powers's famous marble *The Greek Slave* (page 62).

Corcoran opened his art-filled Washington, D.C., home (at the corner of Sixteenth and H Streets, S.W.) to visitors during the 1850s. In 1859 he commissioned the architect James Renwick to design an art museum just a few blocks away, at Seventeenth Street and Pennsylvania Avenue, across from the White House. By the time the gallery opened in 1874 (having been delayed by the Civil War), the collection had expanded from W. W. Corcoran's

original seventy-eight paintings and sculptures to more than three hundred works. Soon afterward, an art school, now the Corcoran College of Art and Design, was established adjacent to the gallery.

A patriotic man (despite his secessionist sympathies during the Civil War), Corcoran was determined that his museum become the national gallery of its time. To that end, with Corcoran's active involvement, the new museum continued to collect contemporary American art, displaying it alongside contemporary European works and casts of ancient sculpture. In 1876, for example, the Corcoran purchased Frederic Edwin Church's majestic *Niagara* (page 79). Many other living artists were eager to have their works represented in the prestigious Corcoran; in 1878 Albert Bierstadt succeeded in selling the Gallery his massive view of an imaginary scene titled *Mount Corcoran* (page 82). During the same decade, Corcoran carried his nationalistic mission even further, adding likenesses of American presidents and other dignitaries to the museum.

By 1891, three years after Corcoran's death, the collection had grown so dramatically that it could no longer be displayed in Renwick's building, and a larger plot of land was purchased a few blocks away, at Seventeenth Street and New York Avenue. Ernest Flagg was commissioned to design the Beaux-Arts style building that is the museum's current home, which was completed in 1897.

Once the Corcoran settled into this expanded facility, the museum continued to collect American art. Its European collections were soon significantly augmented as well, thus building on Corcoran's original desire that American viewers see their native art alongside European examples. In 1925 U.S. Senator William Andrews Clark of Montana bequeathed to the Corcoran his fine collection of European art, which includes excellent examples of Dutch, Flemish, and French paintings plus the Salon Doré, an eighteenth-century French period room. Charles Platt designed a wing to house the Clark collection, which opened in 1928, nearly doubling the size of the museum. A second major European collection came in 1937 as the bequest of Edward and Mary Walker, including French painting from the late nineteenth and early twentieth centuries.

In the years since the Clark wing was completed, many purchases and gifts, notably those resulting from the Biennials, have strengthened the Gallery's holdings of American art. Through these exhibitions, outstanding examples of American Impressionism and other late-nineteenth-century movements, as well as early-twentieth-century realism, were added to the Corcoran's noted collection of Hudson River School paintings. Childe Hassam's Impressionist canvases, realist works by Winslow Homer, paintings by the American expatriate John Singer Sargent, and

important paintings by the early-twentieth-century realists William Glackens, Edward Hopper, and John Sloan are among the many masterworks acquired from Corcoran Biennials. The tradition of purchasing Biennial works continues to this day; in recent years, acquisitions have included works by Ida Applebroog, Robert Mangold, Sean Scully, and Jessica Stockholder. The Corcoran Women's Committee, founded in 1953, has supported many purchases, often those made from the Biennials, and acquisitions were an important motivation in the 1961 founding of the Friends of the Corcoran. Over the years, additions to the collection have also been funded by the William A. Clark Fund, the Anna E. Clark Fund, and the Gallery Fund.

Many important individual donors have followed in W. W. Corcoran's footsteps through their gifts, bequests, and funding for purchases. The 1941 James Parmelee bequest added a broad range of significant American paintings and sculpture to the collection. In 1949 John Singer Sargent's sisters, Miss Emily Sargent and Mrs. Violet Ormond, donated an extensive collection of outstanding drawings by this esteemed artist. The drawings, along with the Corcoran's five oils by Sargent, make him one of the best-represented artists in the collection. Olga Hirshhorn has donated more than twenty works of American and European modern and contemporary art. A significant

gift of thirty-four African-American works and an important archive and library were the 1996 gift of Thurlow Evans Tibbs, Jr. Other donors include the artists themselves, from the turn-of-the-century sculptor Bessie Potter Vonnoh, who bequeathed most of her life's work to the Corcoran (likely because of its art school), to the twentieth-century artists Joseph Goldyne, Manuel Neri, and Dennis Oppenheim. In 1998 the photographer Gordon Parks donated 227 of his works to the museum.

The Corcoran's collection is characterized by great breadth as well as significant depth. As the collection and other aspects of the museum and the College of Art and Design continue to expand beyond the capacity of the Flagg building and Platt wing, the Corcoran is embarking on plans to improve and expand these spaces. Within the first few years of the twenty-first century, the building's first renovation and addition since 1928 will be undertaken, to be designed by the internationally acclaimed architect Frank Gehry. The Corcoran will thus continue to carry the pioneering spirit of William Wilson Corcoran into the new millennium.

Sarah Cash
Bechhoefer Curator of American Art

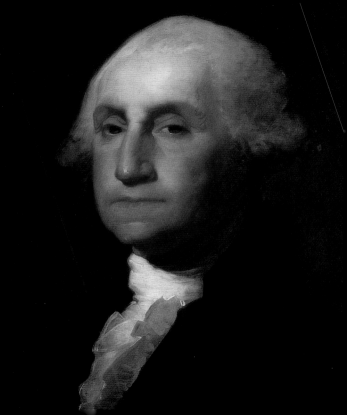

THE COLONIAL AND FEDERAL PERIODS

American painting of the eighteenth and early nineteenth centuries, though limited primarily to portraiture, developed rapidly and underwent significant changes. As the merchant class expanded during this period, so did the number of painters eager to document their patrons' newfound wealth and social prominence in ambitious likenesses. These American-born and European émigré artists ranged from self-taught limners who learned by copying mezzotints to painters who had spent years studying in Italy and England.

John Smibert, a London-trained Scottish immigrant who was the leading New England portraitist of the eighteenth century, was highly successful and extremely prolific. Pragmatic patrons such as the Boston merchant and shipbuilder Peter Faneuil (page 20) enthusiastically embraced Smibert's realistic portrayals over more idealized depictions. Despite reliance on some English Baroque conventions, these direct, truthful renderings became the hallmark of Colonial painting in New England. They were favored as models by Smibert's American-born followers—for

example, Robert Feke (page 21), whose meager training resulted in his own unique style.

The Baltimore portraitist Joshua Johnson, the first known African-American to become a professional painter, portrayed his well-to-do white subjects in simple compositions. His charming, if somewhat stiff, figures are often linked by carefully chosen gestures and decorative details like the fruit, parasol, and graceful curve of the sofa seen in *Mrs. Hugh McCurdy and Her Daughters* (opposite). Other artists brought the latest in London portrait styles to their sitters (and to their fellow artists) in both New England and the South. Many, like the English immigrant John Wollaston, tended to idealize their sitters; the almond-shaped eyes of Mrs. Sidney Breese (page 23) are a feature that recurs in many of his portraits.

The genius of Colonial portraiture was Bostonian John Singleton Copley, who had an unprecedented skill for sharp observation, as in his spirited portrayal of Thomas Amory II (page 24). Here, Copley demonstrated his ability to capture not only the rich textures and surfaces of his sitters' clothing but also their personalities; Amory's contemplative pose, with his head turned and his hands resting on a cane, gives him a distinguished yet cerebral air.

In marked contrast to Copley's precise, hard style is the painterly manner of the influential portraitist Gilbert Stuart. The key figure in the transition from the Colonial

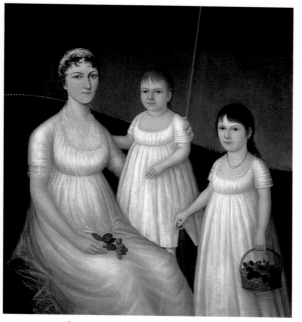

JOSHUA JOHNSON (active 1796–1824)
Mrs. Hugh McCurdy and Her Daughters, c. 1804
Oil on canvas, 44 x 38¾ in. (111.8 x 98.4 cm)

to the Federal style, the prolific Stuart painted, and often idealized, many society and political figures. Working first in London and later in Washington and Boston, he is best known for his images of George Washington (page 30). Artists such as the popular Philadelphian Thomas Sully further developed Stuart's painterly style, often by referring to English prototypes. Portraits such as Sully's *William B. Wood as "Charles de Moor"* (page 32) are infused with dramatic gesture, lighting, and atmospheric effects, all described with free brushwork. Sully's fellow Philadelphians James and Rembrandt Peale, sons of the artist Charles Willson Peale, were also successful portrait painters. James painted miniatures on ivory (page 28), while the more successful Rembrandt created larger scale portraits of dignitaries (page 38).

The country's growth and increasing independence during the federal period meant that portrait painting alone was not sufficient to convey a new national identity. Artists began to create heroic narrative paintings done in the Grand Manner, which echoed the traditions of European art in elements that ranged from the poses of classical antiquity to the compositions and palettes of the old masters. Rembrandt Peale's massive equestrian portrait of George Washington at Yorktown (page 39) belongs to this style, as do Samuel F. B. Morse's *Old House of Representatives* (page 37) and Benjamin West's *Cupid Stung by a*

Bee (page 26). These changes also led to the country's first forays into landscape and still-life painting. Artists like the still-life painter Charles Bird King and like Alvan Fisher and Joshua Shaw, whose canvases celebrate the American landscape, set the stage for the full development of these two genres of painting later in the nineteenth century.

Often paralleling the academic tradition in American art was the folk, or naïve, idiom in painting and sculpture. Naïve artists, though usually aware of the high-style manner, chose to work outside it and, as a result, produced highly distinctive objects. The untrained itinerant painter Frederick Kemmelmeyer, for example, worked in Maryland, Washington, and Virginia, where he advertised his portrait-painting services in local newspapers. His often pastel-colored portraits (page 29) are characterized by careful rendering of costumes and settings, but reveal little interest in his sitters' personalities. Some artists, such as the wood-carver William Rush (page 31), began working in the artisan tradition but later made the transition to grander, more conventional styles.

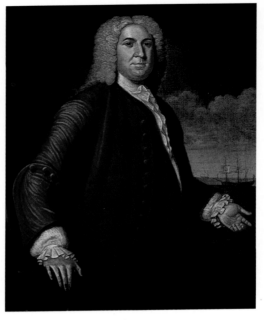

JOHN SMIBERT (1688–1751)
Peter Faneuil, c. 1742
Oil on canvas, 49¾ x 40 in. (126.4 x 101.6 cm)

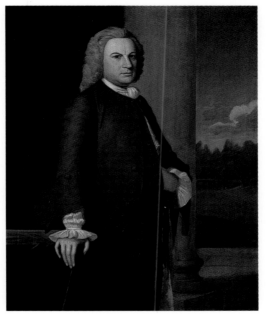

ROBERT FEKE (c. 1706–c. 1752)
Simon Pease, c. 1749
Oil on canvas, 50½ x 40 in. (128.3 x 101.6 cm)

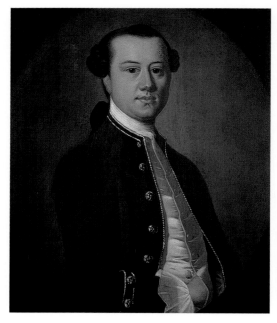

JEREMIAH THEUS (c. 1719–1774)
Mr. Jones, c. 1750
Oil on canvas, 29⅝ x 24⅝ in. (75.3 x 62.6 cm)

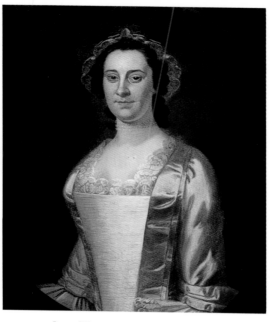

JOHN WOLLASTON (active 1736–1767)
Mrs. Sidney Breese (Elizabeth Penkethann), c. 1750
Oil on canvas, 30 x 25⅛ in. (76.2 x 63.8 cm)

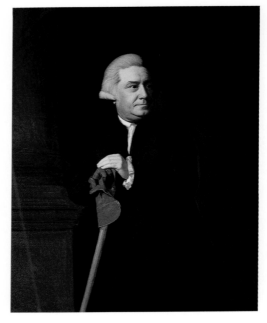

JOHN SINGLETON COPLEY (1738–1815)
Thomas Amory II, c. 1770–72
Oil on canvas, 50 x 40⅛ in. (127 x 101.9 cm)

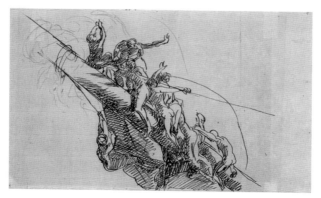

JOHN SINGLETON COPLEY (1738–1815)
Figures Clinging to Wreckage (Study for *Siege and Relief of Gibraltar*,
1787-91, oil on canvas, National Gallery, London), 1785-86
Brown ink on beige paper, 8 x 12⅞ in. (20.3 x 32.7 cm)

BENJAMIN WEST (1738–1820)
Cupid Stung by a Bee, 1774
Oil on canvas, 47¾ x 48⅞ in. (121. 3 x 124.1 cm)

JAMES PEALE (1749–1831)
Mrs. John F. Van Ness (Marcia Burns), 1797
Watercolor on ivory, 2¾ x 2½ in. (7 x 6.4 cm)

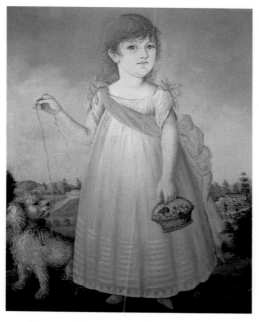

FREDERICK KEMMELMEYER (active 1788–1821)
Charlotte Marstellar, c. 1803
Oil on canvas, 29¾ x 24¼ in. (75.6 x 61.6 cm)

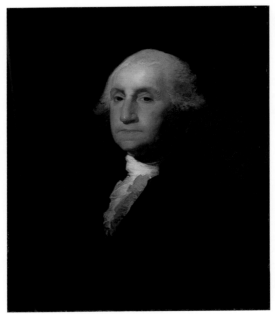

GILBERT STUART (1755–1828)
George Washington, c. 1800
Oil on canvas, 29⅞ x 24½ in. (75.9 x 62.2 cm)

WILLIAM RUSH (1756-1833)
Linnaeus (Carl von Linné), c. 1812
Wood, 24¾ x 17½ x 12½ in. (62.9 x 44.5 x 31.8 cm)

THOMAS SULLY (1783–1872)
William B. Wood as "Charles de Moor," 1811
Oil on canvas, 42¼ x 30⅛ in. (107.3 x 76.5 cm)

CHARLES BIRD KING (1785–1862)
Poor Artist's Cupboard, c. 1815
Oil on panel, 29¾ x 27¾ in. (75.6 x 70.5 cm)

ALVAN FISHER (1792–1863)
Mishap at the Ford, 1818
Oil on panel, 28½ x 35 in. (72.4 x 88.9 cm)

JOSHUA SHAW (1776–1860)
Landscape with Deer, North Carolina, c. 1818–21
Watercolor and gouache over graphite on off-white paper,
9 x 13½ in. (22.9 x 34.3 cm)

WASHINGTON ALLSTON (1779–1843)
Sketch of a Polish Jew, 1817
Oil on canvas, 30¼ x 25¼ in. (76.8 x 64.1 cm)

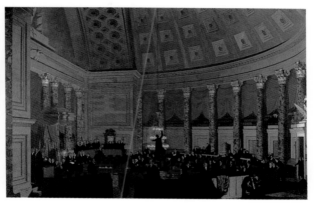

SAMUEL F. B. MORSE (1791–1872)
The Old House of Representatives, 1822
Oil on canvas, 86½ x 130¾ in. (219.7 x 332.1 cm)

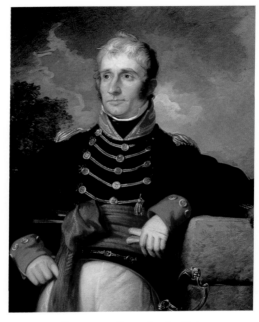

REMBRANDT PEALE (1778–1860)
Lt. Col. Joseph Outen Bogart, c. 1822
Oil on canvas, 36 x 28 in. (91.4 x 71.1 cm)

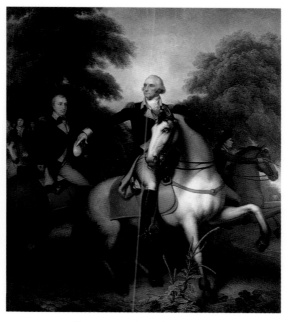

REMBRANDT PEALE (1778–1860)
Washington before Yorktown, 1824/25
Oil on canvas, 139 x 121 in. (353.1 x 307.3 cm)

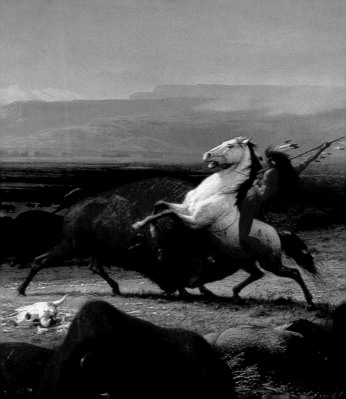

THE ROMANTIC ERA

American paintings and sculpture from about 1825 to 1875—the contemporary art of W.W. Corcoran's day— were the focus of his collecting and today form the core of the Gallery's renowned nineteenth-century American art holdings. Indeed, Corcoran, an urban businessman, was typical of the nineteenth-century patrons who commissioned or purchased naturalistically painted canvases depicting peaceful landscapes, simple scenes of rural life, and bountiful still lifes. Living with such scenes helped ease the pressures of urban life and industrialization brought on by the dramatic economic, social, and political changes during the middle decades of the nineteenth century.

By about 1825 the first native school of landscape painting began to flourish under the leadership of Thomas Cole. It came to dominate American art during the Romantic period, when artists and patrons wanted to celebrate the uniqueness of the country's terrain and the settlers' experiences within it. Eager to convey the widely held nineteenth-century belief that God was omnipresent in nature, many artists struggled to capture every land-

scape detail, from blades of grass to sunsets. Cole typically took this symbolism one step further, as in *The Departure* (page 50) and *The Return* (page 51); by contrasting spring to autumn, sunrise to sunset, the start of war to the end of the battle, these canvases moralize about the transitory character of human life compared to the eternal presence of nature.

Cole's followers venerated the natural wonders of the northeastern United States, creating works that ranged from majestic views of forest interiors such as Asher B. Durand's *Edge of the Forest* (opposite) to contemplative vistas of lakes and rivers such as John William Casilear's *Lake George* (page 64) and Thomas Doughty's *Autumn Scene on the Hudson* (page 49). Cole's prolific and highly successful student Frederic Edwin Church, in his magnificent *Niagara* (page 79), painted the ultimate celebration of the glories of the American landscape and its potential for the new nation.

In search of new subject matter, many artists traveled to Europe and some went to remoter spots, such as South America. They also glorified the discoveries of the American West, creating many scenes symbolic of Manifest Destiny—the belief that Americans had been chosen by God to explore and settle the entire continent, at any cost. Church's archrival Albert Bierstadt is among the best-known chroniclers of the American West. His epic

ASHER B. DURAND (1796–1886)
The Edge of the Forest, 1871
Oil on canvas, 78½ x 64 in. (199.4 x 162.6 cm)

Mount Corcoran (page 82), while actually a synthesis of different Western scenes (there is no real Mount Corcoran), nonetheless provided Eastern armchair travelers with a view of an exotic terrain that most had never seen. The artist's final great Western painting, *The Last of the Buffalo* (page 83) served a similar purpose, although by the time it was exhibited in 1889, taste favored landscapes of less epic proportions.

Genre scenes (depictions of everyday life) and still lifes proved to be as restorative to urban dwellers as landscape paintings. Middle-class patrons in the era of Jacksonian Democracy craved simple scenes depicting such everyday events as waiting for a train (page 53) or a stagecoach (page 71) or shoeing a horse, as in Frank Blackwell Mayer's *Leisure and Labor* (page 75). Pictures of family gatherings such as Richard Norris Brooke's *A Pastoral Visit, Virginia* (page 91) had great popular appeal, and carefully arranged still lifes such as Severin Roesen's composition of colorful, abundant flowers and fruit (page 58) graced the dining rooms of many grand houses. Patrons also desired scenes describing Native American life, such as Seth Eastman's *Lacrosse Playing among the Sioux Indians* (page 57), and sporting views like William Tylee Ranney's *Duck Shooting* (page 70)—both in W.W. Corcoran's original collection.

Though no longer the dominant genre by midcentury, portraiture, in painting and sculpture, continued to

be important until the popularization of photography in the third quarter of the nineteenth century. Portraiture played a significant role in W.W. Corcoran's collection—see Thomas Sully's depiction of Andrew Jackson (page 54), for example—as well as in the Gallery's later acquisitions, including George Peter Alexander Healy's portrait of Abraham Lincoln (page 67). Although historical, mythological, and religious subjects played lesser roles in the mid-nineteenth century, Neoclassical sculpture often treated such themes in earnest. A highlight of the Gallery's sculpture collection is Hiram Powers's *Greek Slave* (page 62), commissioned by W.W. Corcoran from the artist as the first of five replicas. The first American sculpture to depict a completely nude human figure, Powers's marble was highly acclaimed in its day, despite some controversy over the idea of displaying a nude to conservative American audiences.

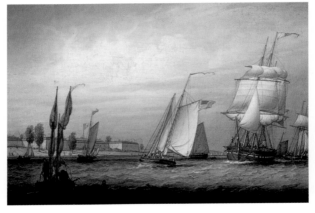

ROBERT SALMON (1775–after 1843)
Boston Harbor, 1843
Oil on panel, 16¼ x 24¼ in. (41.3 x 61.6 cm)

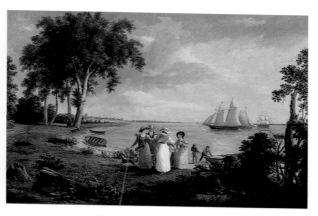

THOMAS BIRCH (1779–1851)
View of the Delaware near Philadelphia, 1831
Oil on canvas, 40 x 60 in. (101.6 x 152.4 cm)

THOMAS DOUGHTY (1793–1856)
Harper's Ferry from Below, c. 1825–27
Pen with black and brown ink and watercolor wash on paper,
7⅛ x 11⅛ in. (18 x 28.3 cm)

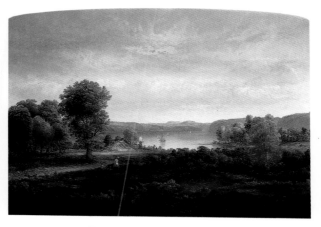

THOMAS DOUGHTY (1793–1856)
Autumn Scene on the Hudson, 1850
Oil on canvas, 34⅜ x 48½ in. (87.3 x 123.2 cm)

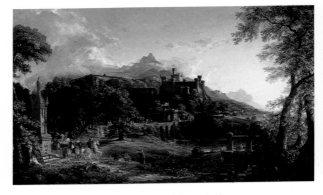

THOMAS COLE (1801–1848)
The Departure, 1837
Oil on canvas, 39½ x 63 in. (100.3 x 160 cm)

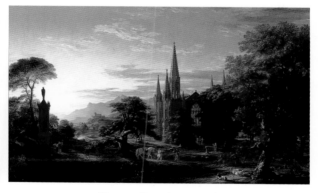

THOMAS COLE (1801–1848)
The Return, 1837
Oil on canvas, 39¾ x 63 in. (101 x 160 cm)

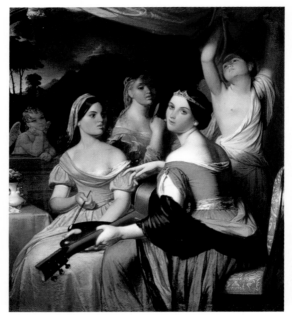

WILLIAM EDWARD WEST (1788–1857)
The Muses of Painting, Poetry and Music, c. 1835
Oil on canvas, 37¾ x 32¾ in. (95.9 x 83.2 cm)

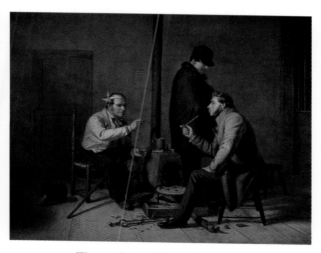

WILLIAM SIDNEY MOUNT (1807–1868)
The Long Story, 1837
Oil on panel, 17 x 22 in. (43.2 x 55.9 cm)

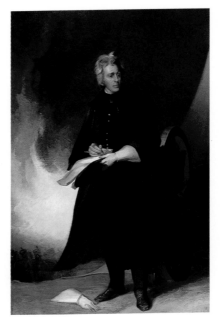

THOMAS SULLY (1783–1872)
General Andrew Jackson, 1845
Oil on canvas, 97¼ x 61½ in. (247 x 156.2 cm)

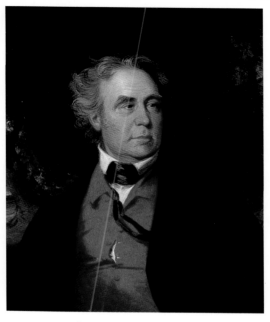

John Neagle (1796–1865)
Colonel Richard Mentor Johnson, 1843
Oil on canvas, 30 x 25 in. (76.2 x 63.5 cm)

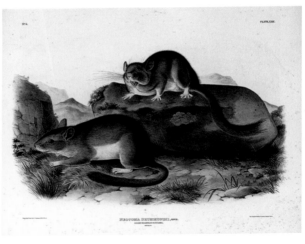

JOHN T. BOWEN (c. 1801–1856?)
After a drawing by John James Audubon (1785–1851)
Rocky Mountain Neotoma, 1843
Hand-colored lithograph, 21 x 27½ in. (53.4 x 69.9 cm)

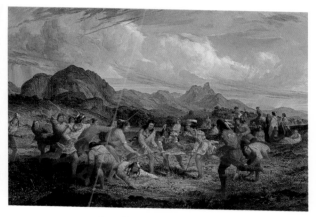

SETH EASTMAN (1808–1875)
Lacrosse Playing among the Sioux Indians, 1851
Oil on canvas, 28¼ x 40¾ in. (71.8 x 103.5 cm)

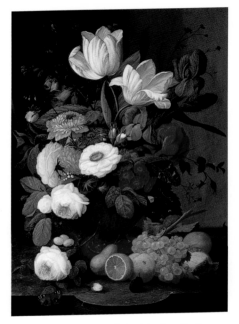

SEVERIN ROESEN (1815/16–after 1872)
Still Life, Flowers and Fruit, 1848
Oil on canvas, 36 x 26 in. (91.4 x 66 cm)

ROBERT S. DUNCANSON (1820–1872)
Fruit Still Life, 1849
Oil on canvas, 13½ x 19 in. (34.3 x 48.3 cm)

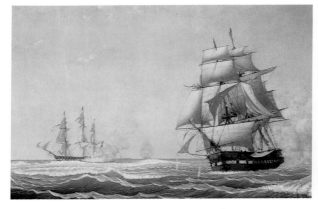

FITZ HUGH LANE (1804–1865)
The United States Frigate "President" Engaging the British Squadron, 1815, 1850. Oil on canvas, 28 x 42 in. (71.1 x 106.7 cm)

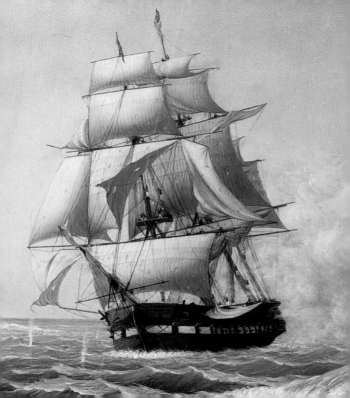

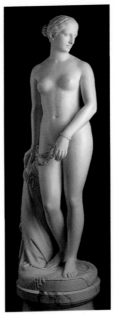

HIRAM POWERS (1805–1873)
The Greek Slave, 1846
Marble, 65 x 19½ in. (165.1 x 49.5 cm)

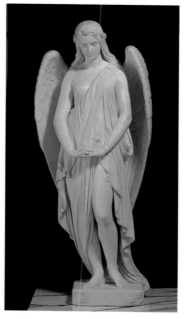

THOMAS CRAWFORD (1813–1857)
Peri at the Gates of Paradise, 1855
Marble, 60 x 27¼ x 18¾ in. (152.4 x 69.2 x 47.6 cm)

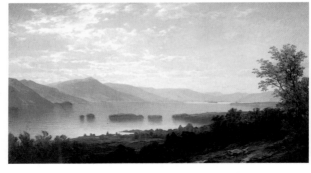

JOHN WILLIAM CASILEAR (1811–1893)
Lake George, c. 1860
Oil on canvas, 25½ x 45¼ in. (64.8 x 114.9 cm)

64

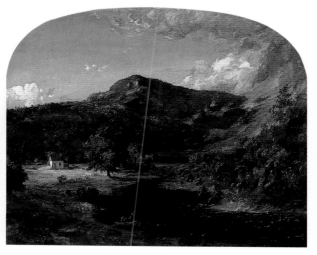

JASPER FRANCIS CROPSEY (1823–1900)
Washington's Headquarters on the Hudson, 1851
Oil on canvas, 23 x 27¾ in. (58.4 x 70.5 cm)

CHARLES LORING ELLIOTT (1812–1868)
James McGuire, 1854
Oil on canvas, 30⅛ x 25 in. (76.5 x 63.5 cm)

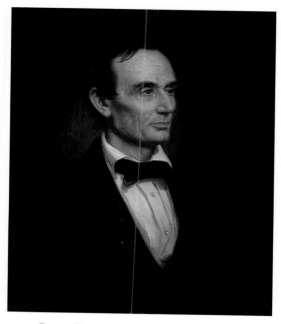

GEORGE PETER ALEXANDER HEALY (1813–1894)
Abraham Lincoln, 1860
Oil on canvas, 30⅜ x 25⅜ in. (77.2 x 64.5 cm)

JOHN FREDERICK KENSETT (1816–1872)
Building by a Dam, c. 1850–60
Graphite with sgraffito on tinted paper, 5¼ x 8⅜ in. (13.3 x 21.3 cm)

JOHN FREDERICK KENSETT (1816–1872)
High Bank, Genesee River, 1857
Oil on canvas, 30½ x 49¼ in. (77.5 x 125.1 cm)

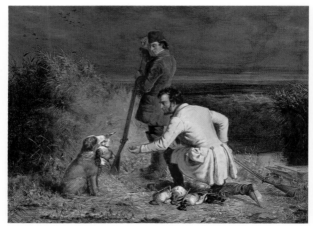

WILLIAM TYLEE RANNEY (1813–1857)
Duck Shooting, 1850
Oil on canvas, 30¼ x 40⅜ in. (76.8 x 102.6 cm)

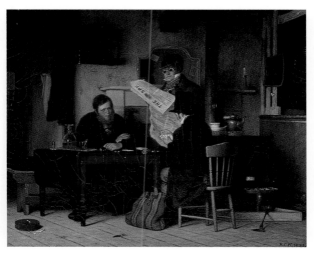

RICHARD CATON WOODVILLE (1825–1855)
Waiting for the Stage, 1851
Oil on canvas, 15 x 18½ in. (38.1 x 47 cm)

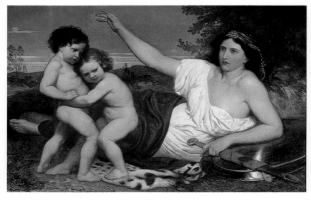

EMANUEL GOTTLIEB LEUTZE (1816–1868)
The Amazon and Her Children, 1851
Oil on canvas, 40½ x 62¼ in. (102.9 x 158.1 cm)

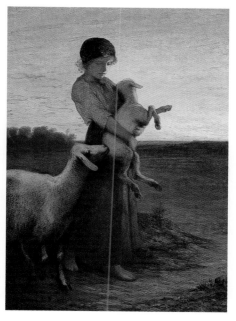

WILLIAM MORRIS HUNT (1824–1879)
The Belated Kid, 1857
Oil on canvas, 54 x 38½ in. (137.2 x 97.8 cm)

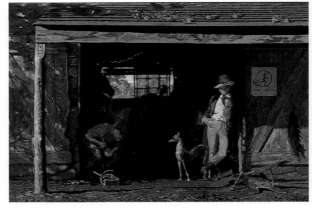

FRANK BLACKWELL MAYER (1827–1899)
Study for "Leisure and Labor," c. 1858
Watercolor and gouache over graphite on paper,
7½ x 9⅛ in. (19.1 x 23.2 cm)

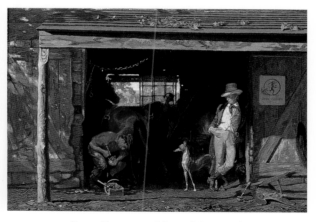

FRANK BLACKWELL MAYER (1827–1899)
Leisure and Labor, 1858
Oil on canvas, 15⅝ x 23 in. (39.7 x 58.4 cm)

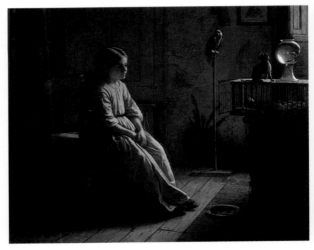

EASTMAN JOHNSON (1824–1906)
Girl and Pets, 1856
Oil on academy board, 25 x 28¾ in. (63.5 x 73 cm)

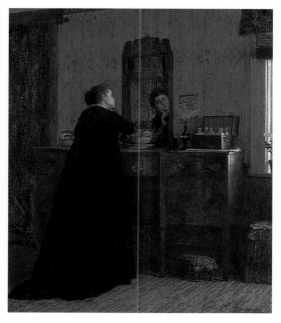

EASTMAN JOHNSON (1824–1906)
The Toilet, 1873
Oil on academy board, 26 x 22 in. (66 x 55.9 cm)

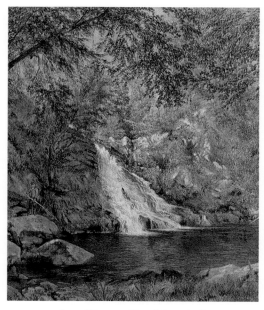

JOHN WILLIAM HILL (1812–1879)
The Waterfall, after 1855
Watercolor and gouache over graphite on paper board,
16⅝ x 13⅞ in. (42.3 x 31.5 cm)

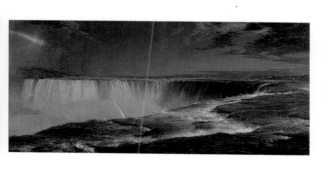

FREDERIC EDWIN CHURCH (1826–1900)
Niagara, 1857
Oil on canvas, 42½ x 90½ in. (108 x 229.9 cm)

WILLIAM LOUIS SONNTAG (1822–1900)
Classic Italian Landscape with Temple of Venus, c. 1860
Oil on canvas, 36 x 60 in. (91.4 x 152.4 cm)

MARTIN JOHNSON HEADE (1819–1904)
View of Marshfield, c. 1865–70
Oil on canvas, 15⅝ x 30¼ in. (39.1 x 76.8 cm)

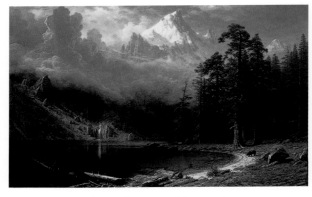

ALBERT BIERSTADT (1830–1902)
Mount Corcoran, 1877
Oil on canvas, 61 x 96¼ in. (154.9 x 244.5 cm)

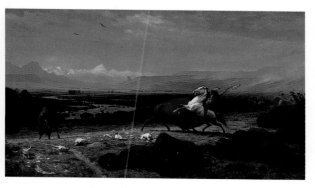

ALBERT BIERSTADT (1830–1902)
The Last of the Buffalo, c. 1889
Oil on canvas, 71¼ x 119¼ in. (181 x 302.9 cm)

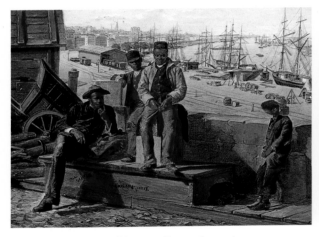

DAVID NORSLUP (dates unknown)
Negro Boys on the Quayside, c. 1865
Oil on panel, 15⅞ x 19½ in. (40.3 x 49.5 cm)

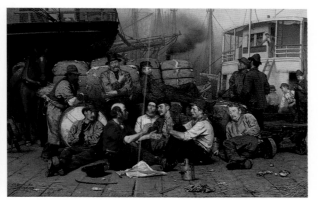

JOHN GEORGE BROWN (1831–1913)
The Longshoremen's Noon, 1879
Oil on canvas, 33¼ x 50¼ in. (84.5 x 127.6 cm)

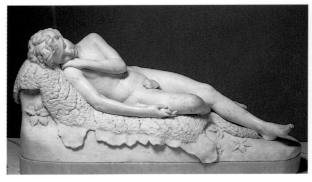

WILLIAM RINEHART (1825–1874)
Endymion, 1874
Marble, 23½ x 50¾ x 16¼ in. (59.7 x 128.9 x 41.3 cm)

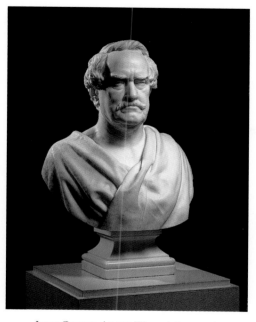

JOHN QUINCY ADAMS WARD (1830–1910)
William Wilson Corcoran, 1883
Marble, 28 x 20 x 13 in. (71.1 x 50.8 x 33 cm)

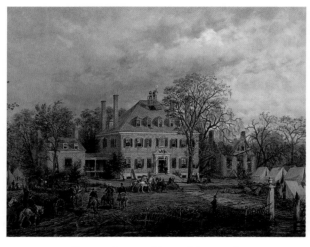

EDWARD LAMSON HENRY (1841–1919)
The Old Westover Mansion, 1869
Oil on panel, 11¼ x 14⅝ in. (28.6 x 37.2 cm)

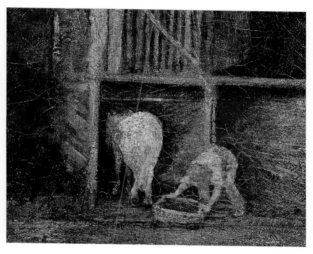

ALBERT PINKHAM RYDER (1847–1917)
The Stable, c. 1875
Oil on canvas, 8 x 10 in. (20.3 x 25.4 cm)

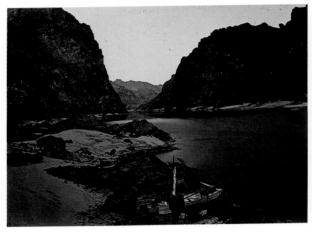

TIMOTHY O'SULLIVAN (1840–1882)
Black Cañon, Colorado River, Looking Above from Camp 7, from
*Geographical and Geological Explorations and Surveys West of the 100th
Meridian,* 1871. Albumen print, 8 x 10⅞ in. (20.3 x 27.6 cm)

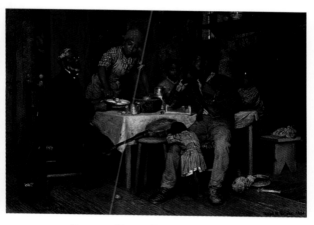

RICHARD NORRIS BROOKE (1847–1920)
A Pastoral Visit, Virginia, 1881
Oil on canvas, 47¾ x 65¾ in. (121.3 x 167 cm)

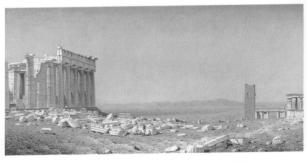

SANFORD ROBINSON GIFFORD (1823–1880)
Ruins of the Parthenon, 1880
Oil on canvas, 27⅝ x 53⅜ in. (70.2 x 135.6 cm)

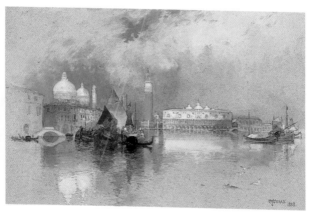

THOMAS MORAN (1837–1926)
View of Venice, 1888
Watercolor and gouache over graphite on gray paper,
10½ x 15⅝ in. (26.7 x 39.7 cm)

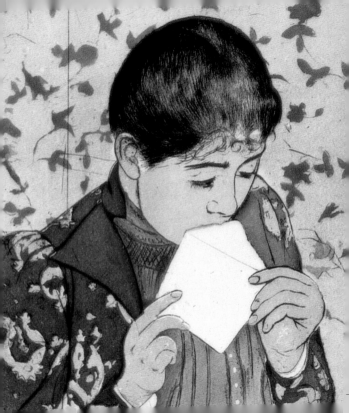

IMPRESSIONISM AND REALISM

By 1875, the year the Corcoran Gallery of Art opened to the public, the popularity of grand American landscape painting was on the wane. In the years following the Civil War, a diversity of styles and influences placed the mid-nineteenth-century focus on Romantic realism. Increasingly, American artists studied abroad and developed a greater interest in the aesthetic aspects of art than in its ability to reproduce nature faithfully.

Many of the paintings in this chapter are important not only as outstanding examples of each artist's work but also because they were exhibited in, and purchased from, the Corcoran's prestigious Biennial of contemporary American art, which began in 1907. Indeed, the Gallery is fortunate to own multiple works (often in different media) by a number of these artists.

Works by George Inness and Worthington Whittredge exemplify the shift from operatic landscape painting toward a more poetic and atmospheric style, one concerned with light, color, individual brush strokes, and tonal relationships. Other artists usually associated with

this change are Thomas Eakins, Winslow Homer, and Eastman Johnson, whose early, more naturalistic styles gave way, in the last decades of the century, to a growing interest in abstraction. Homer's masterful balance of abstraction and realism in *A Light on the Sea* (page 111), for example, is evident in the arrangement of the woman's monumental figure against the alternating light and dark shapes of the coast, sea, and sky. Eakins, whose *Pathetic Song* (page 112) is a masterwork of probing portraiture, greatly influenced a number of realist artists active in the early twentieth century.

Despite their interest in abstraction and European influences, these artists remained essentially realists. Such was not the case with the expatriate painters, the American Impressionists, and the Symbolists. The three leading expatriate painters—James McNeill Whistler, John Singer Sargent, and Mary Cassatt—each worked in a unique personal style that melded their interests in one or more international art movements. Sargent, inspired by the French Impressionists and by the seventeenth-century painters Diego Velázquez and Frans Hals, became a highly successful portraitist of Parisian (page 121), American, and British society. This incredibly versatile artist also created landscapes (page 123), genre pictures (page 120), city views (page 122), and masterful drawings (pages 124 and 125).

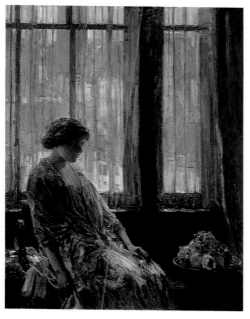

CHILDE HASSAM (1859–1935)
The New York Window, 1912
Oil on canvas, 45½ x 35 in. (115.6 x 88.9 cm)

By the 1890s a number of American artists had studied in Paris and absorbed the tenets of French Impressionism. American artists and patrons developed a nearly insatiable appetite for scenes of modern life painted out of doors. Filled with light, air, and color, these views are rendered in small, vibrant brush strokes. Artists like William Merritt Chase and J. Alden Weir turned to the new style midway through their careers, after studying abroad. Childe Hassam, another leading exponent of Impressionism, adopted the style as a young man, after a three-year sojourn in Paris. He produced luminous paintings of the New England coast (page 139) and figures in sun-dappled interiors (page 97), as well as accomplished watercolors (page 138) and etchings (page 140). Hassam's favored theme of the woman in an interior setting is prevalent in the Corcoran's holdings of American Impressionism, having also been treated masterfully by Edmund Tarbell (page 146), Frank Weston Benson (page 153), and Frederick Carl Frieseke (page 149). In sculpture, too, the modern woman was a popular subject, and the Corcoran is fortunate to own a number of bronzes by Bessie Potter Vonnoh (page 150).

Near the turn of the century a group of American and European artists called the Symbolists expressed their inner visions in vivid colors and often abstract forms rather than objectively describing the world around them. Americans

who painted in this mode during the period known as the American Renaissance include Elihu Vedder and Thomas Dewing. However, Ralph Albert Blakelock and Albert Pinkham Ryder are the two painters most often associated with this personal, often nearly abstract mode.

The Corcoran's collection is distinguished by a number of late-nineteenth-century bronzes. In addition to the Bessie Potter Vonnoh bequest, the museum possesses strong holdings of Western sculpture by Frederic Remington, Herman A. MacNeil, and Alexander Phimister Proctor, as well as sculptures by Augustus Saint-Gaudens, Frederick William MacMonnies, and Thomas Eakins.

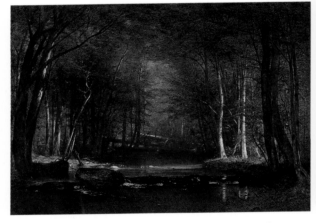

THOMAS WORTHINGTON WHITTREDGE (1820–1910)
Trout Brook in the Catskills, 1875
Oil on canvas, 35½ x 48⅜ in. (90.2 x 122.9 cm)

GEORGE INNESS (1825–1894)
Sunset in the Woods, 1891
Oil on canvas, 48 x 70 in. (121.9 x 177.8 cm)

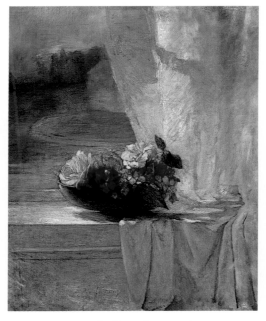

JOHN LA FARGE (1835–1910)
Flowers on a Window Ledge, c. 1862
Oil on canvas, 24 x 20 in. (61 x 50.8 cm)

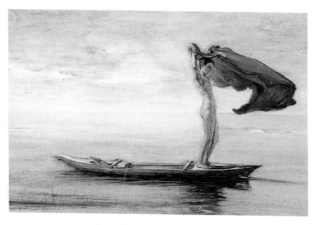

JOHN LA FARGE (1835–1910)
*Fayaway (Girl in Bow of Canoe Spreading Out Her Loin-Cloth
for a Sail, Samoa),* c. 1895–96
Watercolor and gouache over graphite on off-white Japanese paper
laid down on artist's board, 15¼ x 21⅞ in. (38.6 x 55.4 cm)

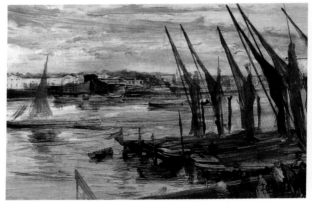

JAMES McNEILL WHISTLER (1834–1903)
Battersea Reach, c. 1865
Oil on canvas, 20 x 30 in. (50.8 x 76.2 cm)

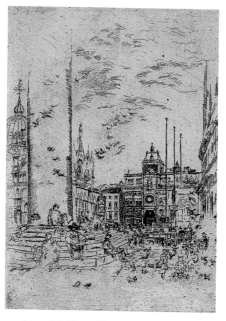

JAMES MCNEILL WHISTLER (1834–1903)
The Piazzetta, 1880
Etching, 10⅝ x 7⅛ in. (27 x 18.1 cm)

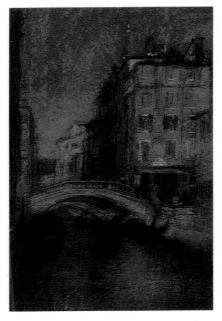

JAMES McNEILL WHISTLER (1834–1903)
A Canal in Venice, c. 1880
Pastel on brown paper, 11½ x 8 in. (29.2 x 20.3 cm)

WILLIAM TROST RICHARDS (1833–1905)
The Bell Buoy, 1894
Watercolor on paper, 15⅜ x 24⅛ in. (39.1 x 61.3 cm)

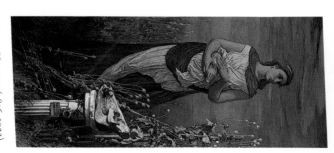

ELIHU VEDDER (1836–1923)
In Memoriam, 1879
Oil on canvas, 44⅛ x 20 in. (112.1 x 50.8 cm)

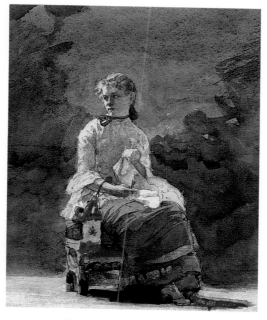

WINSLOW HOMER (1836–1910)
Woman Sewing, c. 1879
Watercolor over graphite on paper, 9¾ x 7⅞ in. (24.8 x 19.9 cm)

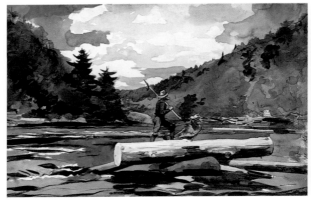

WINSLOW HOMER (1836–1910)
"Hudson River," Logging, 1892
Watercolor and graphite on paper, 14 x 20¾ in. (35.6 x 52.7 cm)

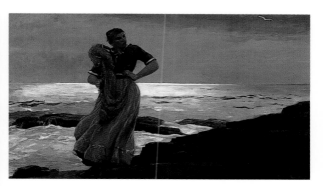

WINSLOW HOMER (1836–1910)
A Light on the Sea, 1897
Oil on canvas, 28¼ x 48¼ in. (71.8 x 122.6 cm)

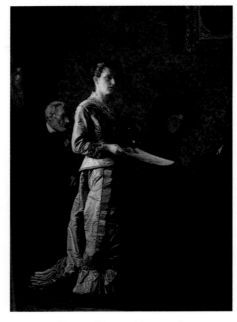

THOMAS EAKINS (1844–1916)
The Pathetic Song, 1881
Oil on canvas, 45 x 32½ in. (114.3 x 82.6 cm)

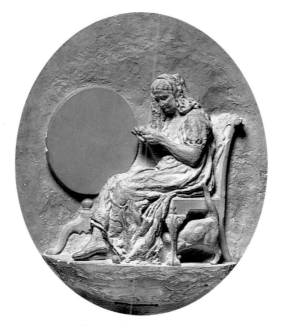

THOMAS EAKINS (1844–1916)
Knitting, 1881
Plaster, 18½ x 14⅞ in. (47 x 37.8 cm)

WILLIAM MICHAEL HARNETT (1848–1892)
Plucked Clean, 1882
Oil on canvas, 34⅛ x 20¼ in. (86.7 x 51.4 cm)

LOUIS MAURER (1832–1932)
Still Life, "Trilby," c. 1895
Oil on canvas, 19 x 28 in. (48.3 x 71.1 cm)

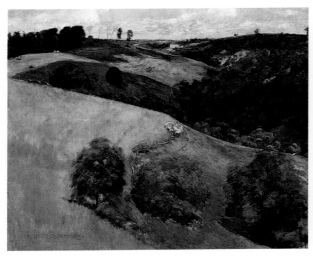

KENYON COX (1856–1919)
Flying Shadows, 1883
Oil on canvas, 30 x 36¼ in. (76.2 x 92.1 cm)

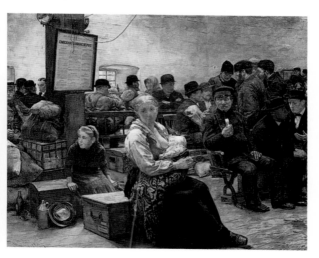

CHARLES FREDERIC ULRICH (1858–1908)
In the Land of Promise, Castle Garden, 1884
Oil on panel, 28⅜ x 35¾ in. (72.1 x 90.8 cm)

MARY CASSATT (1845–1926)
Young Girl at a Window, c. 1883
Oil on canvas, 39½ x 25½ in. (100.3 x 64.8 cm)

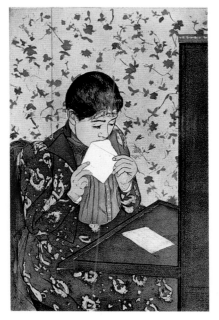

MARY CASSATT (1845-1926)
The Letter, 1891
Etching, drypoint, and aquatint, 13¾ x 9 in. (34.9 x 22.9 cm)

JOHN SINGER SARGENT (1856–1925)
The Oyster Gatherers of Cancale, 1878
Oil on canvas, 31⅛ x 48½ in. (79.1 x 123.2 cm)

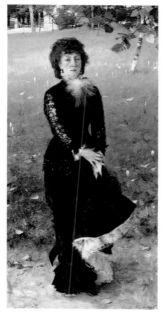

JOHN SINGER SARGENT (1856–1925)
Madame Edouard Pailleron, 1879
Oil on canvas, 82 x 39½ in. (208.3 x 100.3 cm)

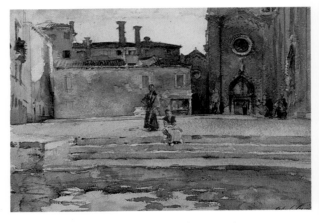

JOHN SINGER SARGENT (1856–1925)
Campo dei Frari, c. 1880
Watercolor over pencil with gouache on paper,
9⅞ x 14 in. (25.1 x 35.6 cm)

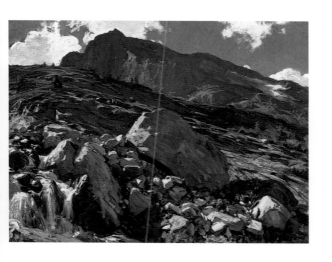

JOHN SINGER SARGENT (1856–1925)
Simplon Pass, 1911
Oil on canvas, 28¼ x 36½ in. (71.8 x 92.7 cm)

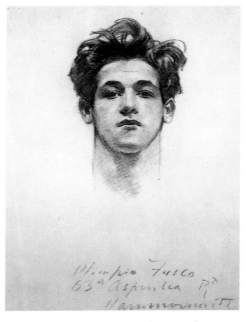

JOHN SINGER SARGENT (1856–1925)
Olimpio Fusco, c. 1900–1915
Charcoal and stump on paper, 24½ x 18⅝ in. (62.2 x 43.3 cm)

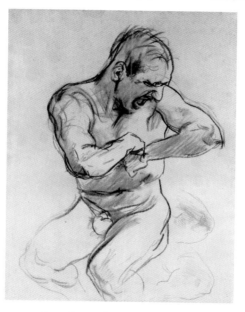

JOHN SINGER SARGENT (1856–1925)
Man Screaming, Study for "Hell," c. 1890–1916
Charcoal and stump with pencil on paper,
24⅜ x 18¾ in. (61.9 x 47.6 cm)

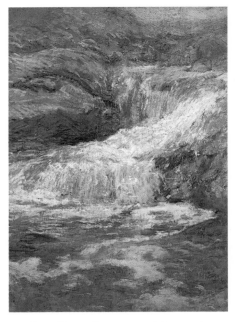

JOHN HENRY TWACHTMAN (1853–1902)
The Waterfall, c. 1890–1900
Oil on canvas, 30¼ x 22¼ in. (76.8 x 56.5 cm)

THEODORE ROBINSON (1852–1896)
Valley of the Seine from Giverny Heights, 1892
Oil on canvas, 25⅞ x 32⅛ in. (65.7 x 81.6 cm)

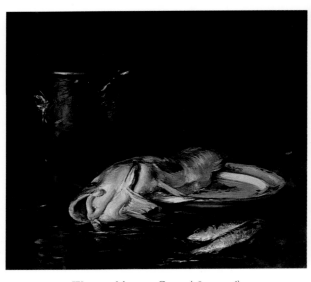

WILLIAM MERRITT CHASE (1849–1916)
An English Cod, 1904
Oil on canvas, 36¼ x 40¼ in. (92.1 x 102.2 cm)

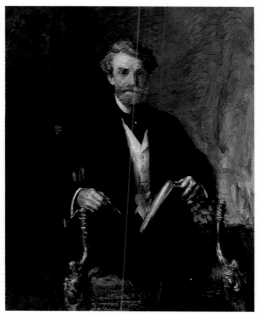

WILLIAM MERRITT CHASE (1849–1916)
William Andrews Clark, c. 1915
Oil on canvas, 50½ x 40¼ in. (128.3 x 102.2 cm)

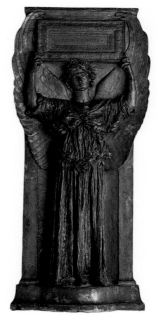

AUGUSTUS SAINT-GAUDENS (1848–1907)
Amor Caritas, 1898
Bronze, 40⅜ x 18½ x 3½ in. (102.6 x 47 x 8.9 cm)

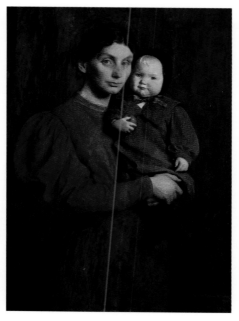

GEORGE DE FOREST BRUSH (1855–1941)
Mother and Child, 1902
Oil on canvas, 38⅛ x 28¾ in. (96.8 x 73 cm)

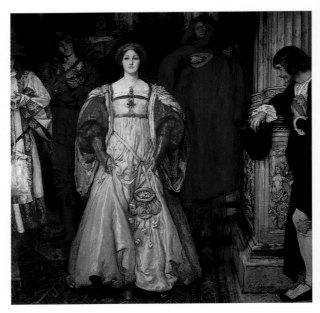

EDWIN AUSTIN ABBEY (1852–1911)
Sylvia, 1899/1900
Oil on canvas, 48¼ x 48¼ in. (122.6 x 122.6 cm)

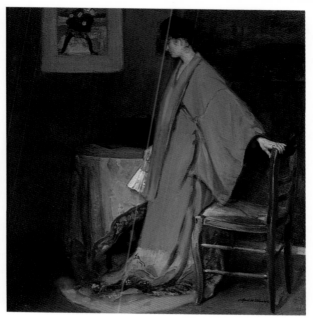

ALFRED H. MAURER (1868–1932)
Young Woman in Kimono, c. 1901
Oil on canvas, 30 x 28¾ in. (76.2 x 73 cm)

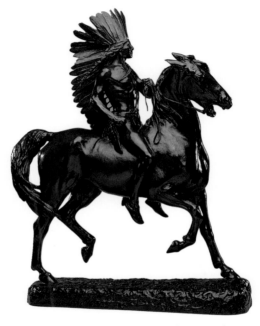

ALEXANDER PHIMISTER PROCTOR (1862–1950)
Indian Warrior, 1898
Bronze, 40 x 16 x 30¼ in. (101.6 x 40.6 x 76.8 cm)

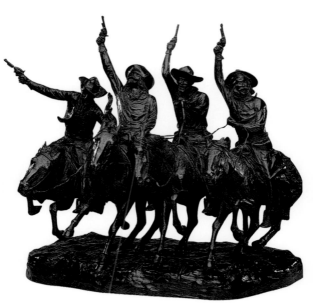

FREDERIC REMINGTON (1861–1909)
Off the Range, 1902
Bronze, 28¾ x 28 x 28⅝ in. (73 x 71.1 x 72.7 cm)

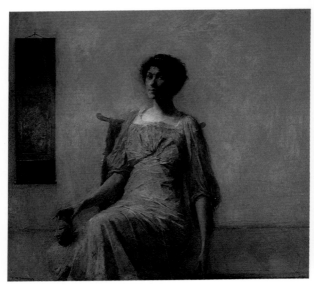

THOMAS WILMER DEWING (1851–1938)
Lady with a Mask, c. 1907
Oil on canvas, 22⅜ x 24¼ in. (56.8 x 61.6 cm)

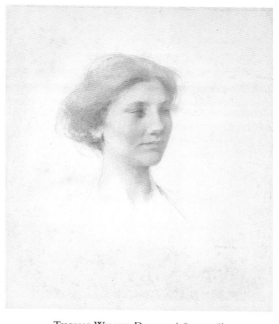

THOMAS WILMER DEWING (1851–1938)
Head of a Girl, c. 1909
Silverpoint on mat board, 13⅝ x 11¾ in. (34.6 x 29.9 cm)

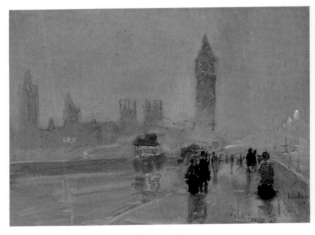

CHILDE HASSAM (1859–1935)
Big Ben, 1897–1907
Gouache and watercolor over charcoal on gray tan paper,
8¾ x 11⅝ in. (22.2 x 29.5 cm)

CHILDE HASSAM (1859–1935)
Northeast Headlands, New England Coast, 1901
Oil on canvas, 25⅛ x 30⅛ in. (63.8 x 76.5 cm)

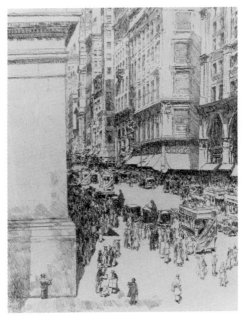

CHILDE HASSAM (1859–1935)
Fifth Avenue, Noon, 1916
Etching, 10 x 7¼ in. (25.4 x 18.4 cm)

WILLARD LEROY METCALF (1858–1925)
May Night, 1906
Oil on canvas, 39½ x 36⅜ in. (100.3 x 92.4 cm)

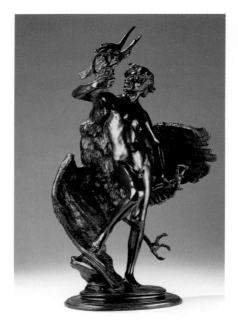

FREDERICK WILLIAM MACMONNIES (1863–1937)
Boy and Heron, 1890
Bronze, 27¾ x 15 x 11¼ in. (70.5 x 38.1 x 28.6 cm)

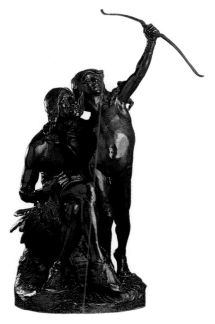

HERMAN A. MACNEIL (1866–1947)
The Sun Vow, 1905
Bronze, 64½ x 36½ x 33½ in. (163.8 x 92.7 x 85.1 cm)

DANIEL GARBER (1880–1958)
April Landscape, 1910
Oil on canvas, 42½ x 46 in. (107.3 x 116.8 cm)

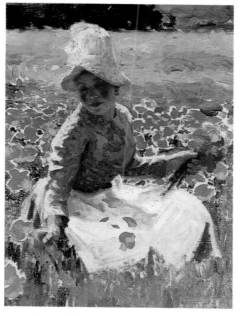

ROBERT WILLIAM VONNOH (1858–1933)
Picking Poppies, c. 1913
Oil on canvas, 15¾ x 11½ in. (40 x 29.2 cm)

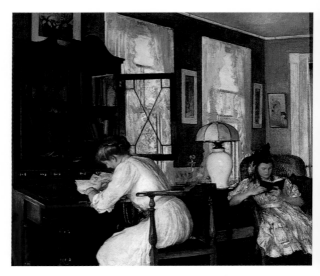

EDMUND TARBELL (1862–1938)
Josephine and Mercie, 1908
Oil on canvas, 28¼ x 32½ in. (71.8 x 81.9 cm)

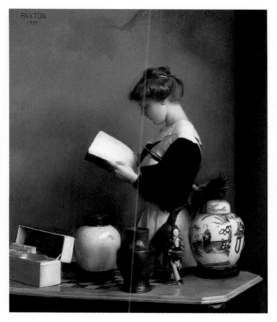

WILLIAM McGREGOR PAXTON (1869–1941)
The House Maid, 1910
Oil on canvas, 30¼ x 25⅛ in. (76.8 x 63.8 cm)

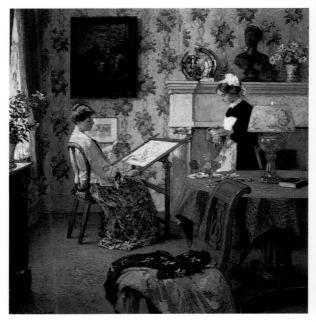

GARI MELCHERS (1860–1932)
Penelope, 1910
Oil on canvas, 54½ x 50⅞ in. (138.4 x 129.2 cm)

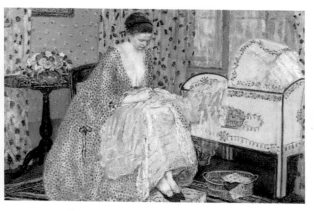

FREDERICK CARL FRIESEKE (1874–1939)
Peace, 1917
Oil on canvas, 40½ x 60⅛ in. (102.9 x 152.7 cm)

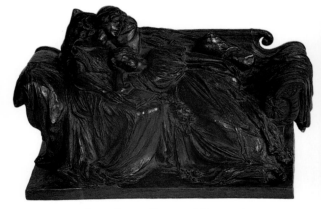

BESSIE POTTER VONNOH (1872–1955)
Daydreams, 1903
Bronze, 10½ x 21¼ x 11 in. (26.7 x 54 x 27.9 cm)

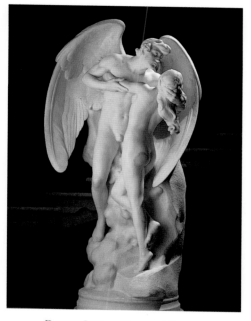

DANIEL CHESTER FRENCH (1850–1931)
The Sons of God Saw the Daughters of Men That They Were Fair, 1923
Marble, 79½ x 42 x 25 in. (201.9 x 106.7 x 63.5 cm)

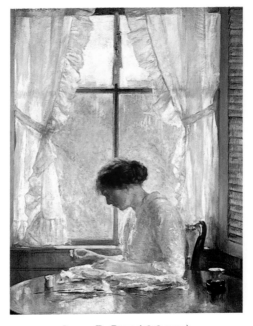

JOSEPH DeCAMP (1858–1923)
The Seamstress, 1916
Oil on canvas, 36¼ x 28 in. (92.1 x 71.1 cm)

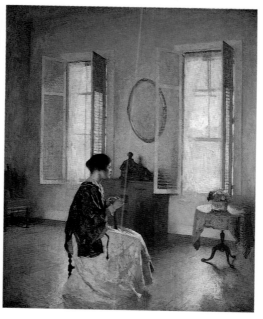

FRANK WESTON BENSON (1862–1951)
The Open Window, 1917
Oil on canvas, 52¼ x 42¼ in. (132.7 x 107.3 cm)

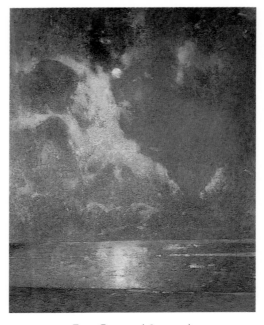

EMIL CARLSEN (1853–1932)
Moonlight on a Calm Sea, 1915/16
Oil on canvas, 58¼ x 47¼ in. (148 x 120 cm)

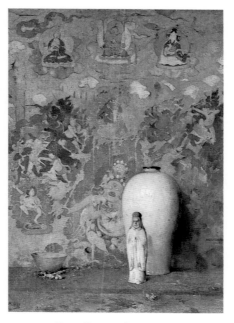

EMIL CARLSEN (1853–1932)
The Picture from Thibet, c. 1920
Oil on canvas, 38⅜ x 27¼ in. (97.5 x 69.2 cm)

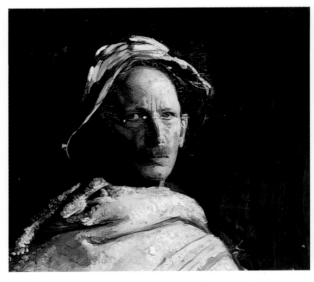

ABBOTT HANDERSON THAYER (1849–1921)
Self-Portrait, 1919
Oil on panel, 22¼ x 24 in. (56.5 x 61 cm)

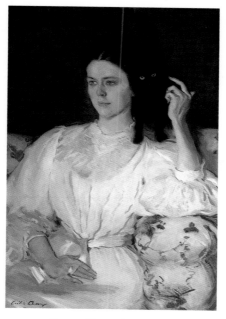

CECILIA BEAUX (1863–1942)
Sita and Sarita, c. 1921
Oil on canvas, 37⅜ x 25⅛ in. (94.9 x 63.8 cm)

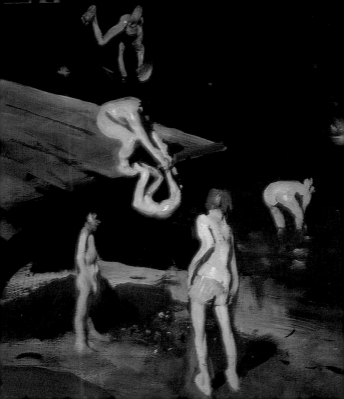

REALISM AND ABSTRACTION:
THE EARLY TWENTIETH CENTURY

The enormous political and social change taking place in America during the early decades of the twentieth century was reflected in the arts. Immediately following the turn of the century, the revival of realism, albeit in a new form, represented a rebellion against the established art academies and the prevailing taste for picturesque American Impressionist scenes. Led by Robert Henri, a group of artists known as the Eight (most of whom were also called the Ashcan painters) celebrated the vitality of the common city dweller and his modern, often gritty, environment, which was well captured by their brash realist style.

Perhaps Henri's closest follower was John Sloan, who produced often satirical prints (page 168) as well as paintings documenting the common activities of urban dwellers, like the scene depicted in *Yeats at Petitpas* (page 169). Similar subjects were taken up by other members of the Eight, including William Glackens and Ernest Lawson, though the latter's Impressionist style little resembled the look of work by Henri and Sloan. Two members of the Eight produced

more poetic views: Maurice Prendergast's nearly abstract mosaics of color describe urban and sometimes seaside outings (pages 164–66), and Arthur B. Davies created dreamlike visions such as *The Umbrian Mountains* (page 181).

A number of younger artists followed in the footsteps of the Eight by taking up the mantle of urban realism. The painter and lithographer George Bellows, who studied with Henri, earned success depicting both the lower classes and high society. His early painting of street urchins swimming at an old pier in Manhattan, *Forty-two Kids* (page 170), was exhibited to great acclaim. Like Bellows, Edward Hopper studied under Henri and was both a printmaker and a painter. Besides his well-known scenes of lonely urban dwellers (page 184), Hopper produced a number of more bucolic paintings while summering on Cape Cod, such as *Ground Swell* (page 185). Though unlike most of his Cape scenes, which generally depict old, seemingly deserted houses, this painting retains the reductiveness and the strong suggestion of isolation and mystery that characterize the artist's best work. More closely allied with the principles of the Ashcan School was Bellows's and Hopper's contemporary Reginald Marsh. In works such as *Smoke Hounds* (page 200), he exposed the harsh realities of crowded, sometimes unhealthy urban life, with particular attention to the down-and-out.

A group of realist painters working in the country's

heartland, far from the art centers of the East Coast, chose to develop their own personal, often somewhat abstracted styles. The most famous of these Regionalists, as they were known, was Thomas Hart Benton. His paintings and murals—usually depicting the working people of the Midwest and their homes, factories, and farms—are characterized by distinctive distortions of form and space.

By the start of the second decade of the twentieth century, the modern art movements that were burgeoning in Europe—Fauvism, Cubism, Dadaism, and Surrealism—challenged the prevailing taste for realism in America. The American public (including most artists) first encountered these avant-garde strains at the Armory Show, held in New York City in 1913. In the years that followed, American artists began to absorb the abstract influences of Paul Cézanne, Henri Matisse, and Pablo Picasso, while developing their own styles and often choosing uniquely American subject matter.

The photographer and dealer Alfred Stieglitz was an important promoter of American modern art and artists, including Arthur Dove and Marsden Hartley. Dove's often subtly toned mature paintings such as *U.S.A.* (page 206) appear abstract but nonetheless are usually tied to nature's forms. Hartley's colorful *Berlin Abstraction* (page 172) is part of his important series of paintings inspired by pre–World War I German militarism; in them, the artist also expressed

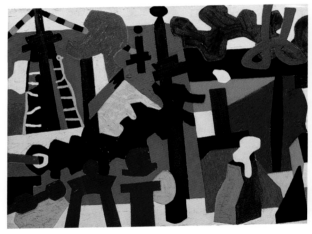

STUART DAVIS (1894–1964)
Study for "Swing Landscape," 1938
Oil on canvas, 22 x 28¾ in. (55.9 x 73 cm)

his sorrow over the recent death of a German officer who had been his lover.

Charles Demuth and Charles Sheeler were significant figures in the Precisionist movement, which took its inspiration from both Cézanne and the Cubists and was characterized by an emphasis on tight pictorial structure and precisely defined lines and planes. Loosely associated with this group was Stuart Davis, who created rhythmic compositions, like *Study for "Swing Landscape"* (opposite), that often evoke the movement and sound of the modern city. Although his emphasis on pure color, line, and form anticipated the total abstraction of postwar art, Davis (a student of Henri) usually retained recognizable elements of the American landscape in his exuberant works.

Like painting, American sculpture of the early twentieth century branched out into a number of new styles, encompassing both realism and abstraction. Sculptors like Daniel Chester French continued the nineteenth-century academic tradition, while Paul Manship developed a new style that combined academic influences and abstract elements in his elegant bronzes (page 174). John Storrs, in contrast, created highly abstract sculptures that are often strongly architectural (page 175). William Edmondson was one of the many African-American sculptors active during the interwar period, which saw the migration of many blacks to northern cities.

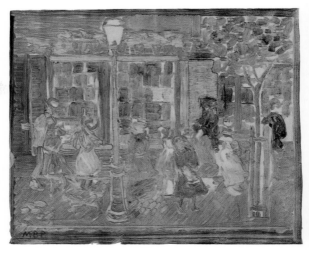

MAURICE PRENDERGAST (1859–1924)
Afternoon, c. 1895–1900
Color monotype on paper, 9 x 10¾ in. (22.9 x 27.3 cm)

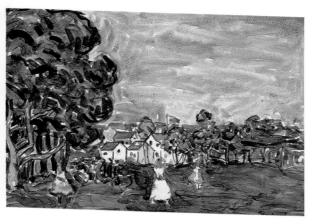

MAURICE PRENDERGAST (1859–1924)
Summer Day, New England, c. 1910–11
Watercolor over charcoal on paper, 12 x 18 in. (30.5 x 45.7 cm)

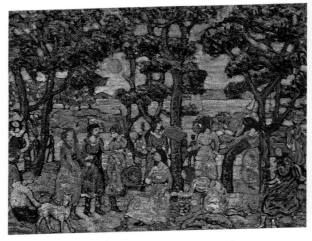

MAURICE PRENDERGAST (1859–1924)
Landscape with Figures, 1921
Oil on canvas, 32⅝ x 42⅝ in. (82.9 x 108.3 cm)

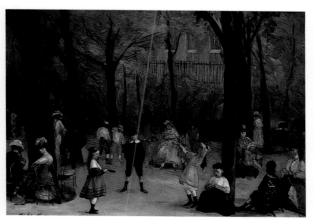

WILLIAM GLACKENS (1870–1938)
Luxembourg Gardens, 1906
Oil on canvas, 23¾ x 32 in. (60.3 x 81.3 cm)

JOHN SLOAN (1871–1951)
Connoisseurs of Prints, 1905
Etching, 4½ x 6¾ in. (11.4 x 17.1 cm)

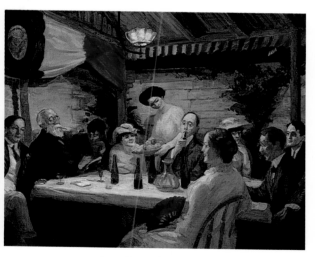

JOHN SLOAN (1871–1951)
Yeats at Petitpas, 1910
Oil on canvas, 26⅜ x 32¼ in. (67 x 81.9 cm)

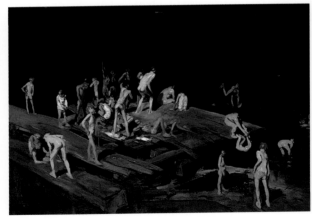

GEORGE BELLOWS (1882–1925)
Forty-two Kids, 1907
Oil on canvas, 42⅜ x 60¼ in. (107.6 x 153 cm)

GEORGE BELLOWS (1882–1925)
The Murder of Edith Cavell, 1918
Lithograph, 18⅞ x 24⅞ in. (47.9 x 63.2 cm)

MARSDEN HARTLEY (1877–1943)
Berlin Abstraction, 1914/15
Oil on canvas, 32 x 26 in. (81.3 x 66 cm)

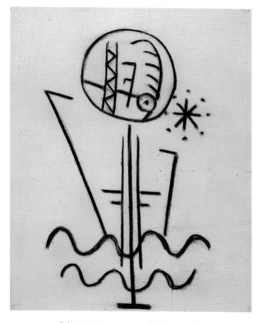

MARSDEN HARTLEY (1877-1943)
Berlin Symbols #6, 1914-15
Charcoal on off-white paper, 25 x 19 in. (63.5 x 48.3 cm)

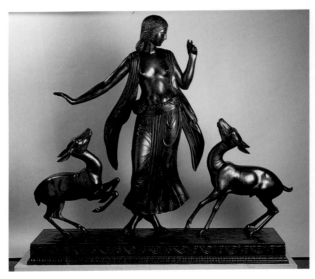

PAUL MANSHIP (1885–1966)
Dancer and Gazelles, 1916
Bronze, 69¾ x 73 x 19 in. (177.2 x 185.4 x 48.3 cm)

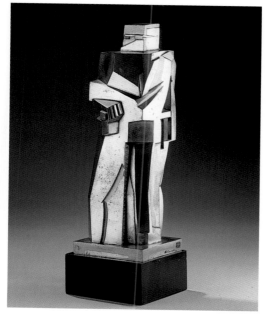

JOHN STORRS (1885–1956)
Le Sergeant de Ville, c. 1920
Bronze with silver gilt, 13¼ x 5¼ x 5¼ in. (33.7 x 13.3 x 13.3 cm)

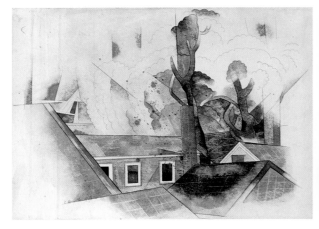

CHARLES DEMUTH (1883–1935)
Rooftops and Trees, 1918
Watercolor and graphite on paper, 10 x 14 in. (25.4 x 35.6 cm)

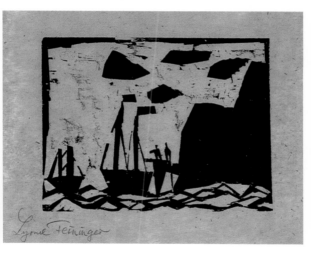

LYONEL FEININGER (1871–1956)
Ships Along a Rocky Coast, 1920
Woodcut, 4¾ x 6 in. (12.1 x 15.2 cm)

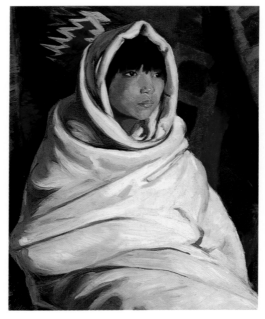

ROBERT HENRI (1865–1929)
Indian Girl in White Ceremonial Blanket, c. 1921
Oil on canvas, 32 x 26 in. (81.3 x 66 cm)

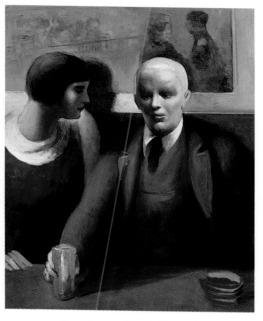

Guy Pène du Bois (1884–1958)
Pierrot Tired, c. 1927
Oil on canvas, 36⅜ x 28⅞ in. (92.4 x 73.3 cm)

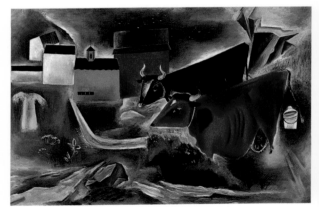

YASUO KUNIYOSHI (1890–1953)
Cows in Pasture, 1923
Oil on canvas, 20 x 30 in. (50.8 x 76.2 cm)

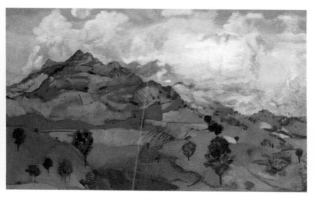

ARTHUR B. DAVIES (1862–1928)
The Umbrian Mountains, 1925
Oil on canvas, 25⅞ x 39⅞ in. (65.7 x 101.3 cm)

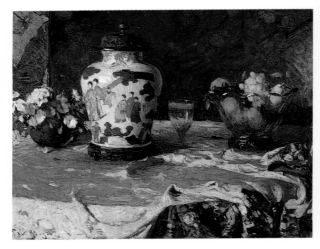

FRANK WESTON BENSON (1862–1951)
Still Life, 1925
Oil on canvas, 32 x 40 in. (81.3 x 101.6 cm)

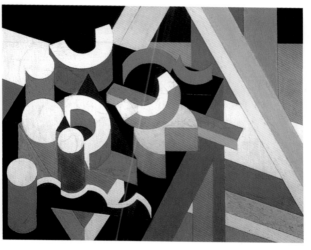

PATRICK HENRY BRUCE (1881–1936)
Peinture/Nature Morte, c. 1925–26
Oil on canvas, 28¾ x 35¾ in. (73 x 90.8 cm)

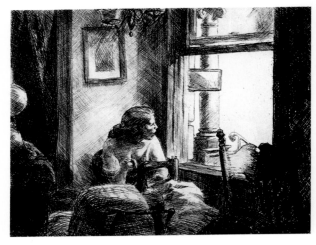

EDWARD HOPPER (1882–1967)
East Side Interior, 1922
Etching, 7⅞ x 9⅞ in. (20 x 25.1 cm)

EDWARD HOPPER (1882–1967)
Ground Swell, 1939
Oil on canvas, 36½ x 50¼ in. (92.7 x 127.6 cm)

CHARLES SHEELER (1883–1965)
Delmonico Building, 1926
Lithograph, 9¾ x 7 in. (24.8 x 17.8 cm)

CHARLES SHEELER (1883–1965)
Western Industrial, 1954
Tempera on plexiglass, 8 x 10 in. (20.3 x 25.4 cm)

FRED KABOTIE (b. 1900)
Hopi Masked Dance, c. 1925–30
Watercolor and gouache on artist board, 19½ x 30 in. (49.6 x 76.2 cm)

OPA MU NU (RICHARD MARTINEZ) (b. 1904)
Design of Leaping Deer, c. 1920–36
Gouache over graphite on paper, 14⅝ x 28 in. (37.1 x 71.1 cm)

ANDRÉ KERTÉSZ (1894–1985)
Quai d'Orléans, Fisherman behind Notre Dame, 1925
Gelatin silver contact print on postcard, 4⅛ x 2½ in. (10.5 x 6.4 cm)

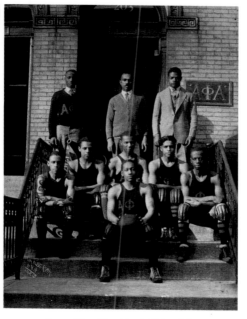

JAMES VAN DER ZEE (1886–1983)
Alpha Phi Alpha Basketball Team, 1926
Gelatin silver print, 9⅜ x 7⅛ in. (23.8 x 18.1 cm)

WALKER EVANS (1903–1975)
Political Poster, Massachusetts Village, 1929
Gelatin silver print, 6¼ x 4½ in. (15.9 x 11.4 cm)

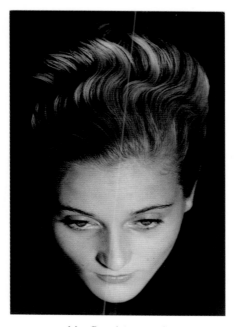

Man Ray (1890–1973)
La Tête, 1930
Gelatin silver print, 11⅛ x 7⅞ in. (28.3 x 20 cm)

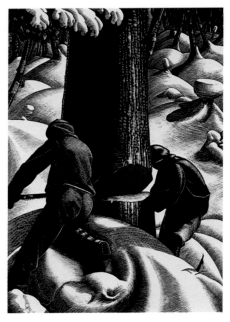

CLARE LEIGHTON (1901–1989)
Cutting, 1931
Wood engraving, 11½ x 8 in. (29.2 x 20.3 cm)

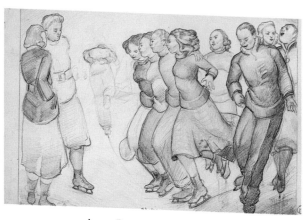

ALLAN ROHAN CRITE (b. 1910)
Skating, 1933
Graphite on paper, 11½ x 15¾ in. (29.2 x 40 cm)

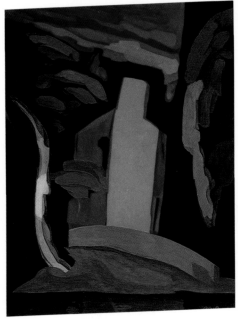

OSCAR BLUEMNER (1867–1938)
Imagination, 1933
Tempera and varnish on paper board, 30¼ x 23 in. (76.8 x 58.4 cm)

PAUL OUTERBRIDGE, JR. (1896–1959)
Toy Display (Circus), c. 1935
Gelatin silver print, 6¼ x 6 in. (15.9 x 15.2 cm)

WILLIAM EDMONDSON (1870–1951)
School Teacher, 1935
Limestone, 14½ x 4⅝ x 7¾ in. (36.8 x 11.8 x 19.7 cm)

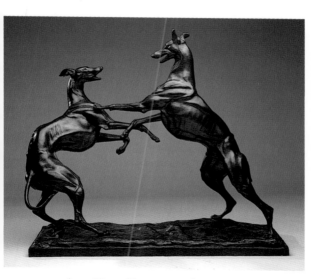

Anna Hyatt Huntington (1876–1973)
Greyhounds Playing, 1936
Bronze, 38⅛ x 39⅞ x 12⅞ in. (96.8 x 101.3 x 32.7 cm)

REGINALD MARSH (1898–1954)
Smoke Hounds, 1934
Egg tempera on Masonite, 36 x 30 in. (91.4 x 76.2 cm)

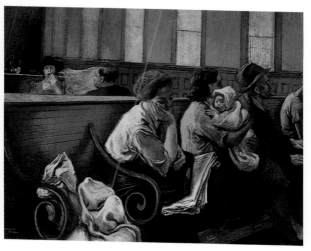

RAPHAEL SOYER (1899–1987)
Waiting Room, c. 1940
Oil on canvas, 34¼ x 45¼ in. (87 x 114.9 cm)

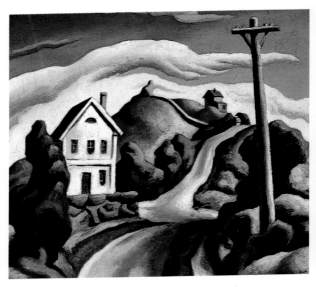

THOMAS HART BENTON (1889–1975)
Landscape, 1930s–40s
Oil on canvas, 21⅝ x 23½ in. (54.9 x 59.7 cm)

DANIEL GARBER (1880–1958)
Ellicott City, Afternoon, 1940
Oil on canvas, 56 x 52 in. (142.2 x 132.1 cm)

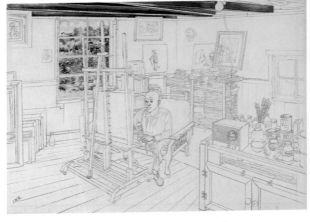

JOHN N. ROBINSON (1912–1994)
In the Studio, 1945
Graphite and watercolor on paper, 18 x 24 in. (45.7 x 61 cm)

REYNOLD WEIDENAAR (1915–1985)
Locomotive Shops, 1947
Etching and aquatint, 12⅞ x 16⅞ in. (32.7 x 42.9 cm)

ARTHUR DOVE (1880–1946)
U.S.A., 1944
Oil on canvas, 23⅞ x 31⅞ in. (60.6 x 81 cm)

JOHN MARIN (1870–1953)
From Flint Isle, Maine—No. 1, 1947
Watercolor over graphite on paper, 15¾ x 20⅞ in. (40 x 53 cm)

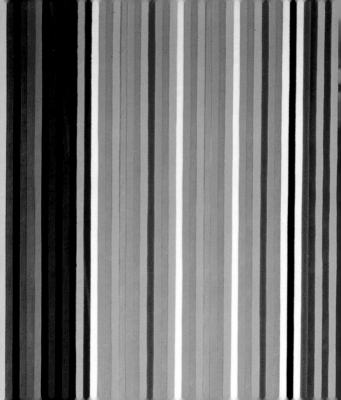

POSTWAR ABSTRACTION
AND REPRESENTATION

The Corcoran's post-1945 collection illustrates how the dual impulses of abstraction and representation have dominated late-twentieth-century American painting and sculpture. Abstract Expressionism predominated in New York, but its impact can also be seen on the Bay Area Figurative movement centered in San Francisco. Both Mark Rothko and Ad Reinhardt taught with David Park at the California School of Fine Arts in San Francisco. Park and his star pupil, Richard Diebenkorn, were influenced significantly by these advocates of Abstract Expressionism. The thick paint surfaces, vibrant color, and expressive brushwork in Park's *Sun Bather* (page 219) and Diebenkorn's *Girl in a Room* (page 226) mirror the abstract gestural approach of *Golden Blaze* (page 222) by another prominent Abstract Expressionist, Hans Hofmann. Washington, D.C., was the epicenter of Color Field painting in the late 1950s. The artists of this informal movement rejected gesture and the illusions of depth, emphasizing instead flatness, geometry, and even a sleek machine-made look. The Corcoran collection

contains many stellar examples of this movement, notably Gene Davis's masterwork *Black Popcorn* (page 231), Kenneth Noland's *Brown Stretched* (page 236), and Thomas Downing's *Seven* (page 237).

By the 1970s, as the art world became less centralized and more international, an ever-expanding array of innovative regional styles gained prominence. Richard Diebenkorn's *Ocean Park #83* (page 227) and Sam Francis's *Untitled* (page 245) are abstractions characterized by a light-filled, distinctively Californian sensibility, whereas Frank Stella's *Botafogo II* (page 249), a synthesis of painting and sculpture, has roots in the pure geometry of Minimalism. At the same time, Roger Brown was exploring a fantastic, cartoony approach to the figure in the landscape, as in *Waterfall* (page 248). In contrast to this Chicago-based Imagist's irreverent take on human foibles, New Yorker Philip Pearlstein favored dynamic, aggressive figurative compositions such as *Reclining Nude on Green Couch* (opposite), which shifts the traditional frontal focus of an odalisque to reinforce the viewer's position as voyeur.

Narrative painting and Neo-Expressionism further altered notions of figuration. Robert Colescott's *Auvers-sur-Oise (Crow in the Wheatfield)* (page 256) and David Bates's *Cottonmouth* (page 268) show how these artists, like many others in the 1980s, rejected the cool austerity of Minimalism in favor of highly charged personal visions.

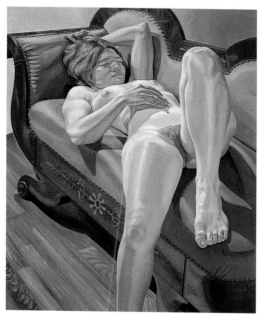

PHILIP PEARLSTEIN (b. 1924)
Reclining Nude on Green Couch, 1971
Oil on canvas, 60 x 48 in. (152.4 x 121.9 cm)

On the other hand, the continuing legacy of Minimalist-inspired geometry is evident in *Five Color Frame Painting* (page 260) by Robert Mangold and *Flyer* (page 261) by Sean Scully. In *Five Color Frame Painting,* a central void is flanked by rectangles of harmonious color unified by line; the architectonic *Flyer* is more expressionistic, recalling Stella's experiments in painted wall sculpture.

In the 1990s artists have increasingly used images of the body to explore race, violence, gender, and sexuality. The insistence by this generation of artists on stretching the boundaries of traditional representation had led them to appropriate images from popular media in order to address social and political themes. Ida Applebroog's *Mother mother I am ill* (page 273) is crowded with a kaleidoscope of image snippets that reveal suggestions of violence and danger in a seemingly innocent children's fable. The humor in Kim Dingle's double portrait, *Black Girl Dragging White Girl* (page 274) diffuses the anger, violence, and overt recognition of racial conflict that dominates her imagery. Lari Pittman transforms quasi-representational images, numbering systems, and text fragments into patterns in *Reverential and Needy* (page 272), in which he addresses sexuality while also bridging the gap between hard-edged graphic representation and formal abstraction.

Two recent acquisitions sum up the increasingly fluid state of contemporary art at the end of the century. In *The

Voyager (page 275) Kerry James Marshall uses painterly allusions to historical events such as the slave trade to explore racial identity. In sculpture, Louise Bourgeois's *Untitled (with foot)* (page 266) may play on the august nineteenth-century tradition of carved marble figures—a particular strength in the Corcoran's collection—but her mysterious and troubling take on the human condition is emphatically about life in the here and now.

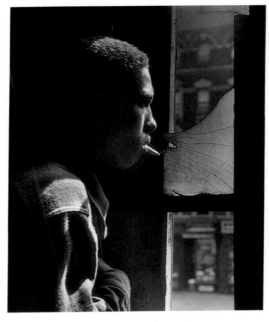

GORDON PARKS (b. 1912)
Red Jackson, Harlem Gang Leader, 1948
Gelatin silver print, 19⅜ x 15⅝ in. (49.2 x 39.7 cm)

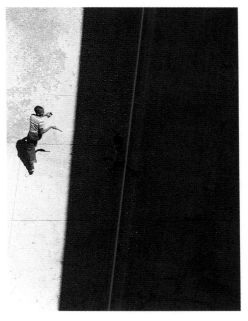

Roy DeCarava (b. 1919)
Sun and Shade, 1952
Gelatin silver print, 12⅞ x 9⅝ in. (32.7 x 24.4 cm)

ANDREW WYETH (b. 1917)
November Fields, Chadds Ford, Pennsylvania, c. 1945–50
Watercolor and graphite on paper, 14⅜ x 20¾ in. (36.5 x 52.7 cm)

STOW WENGENROTH (1906–1978)
Spirit of New England, 1956
Lithograph, 9¼ x 17⅞ in. (23.5 x 45.4 cm)

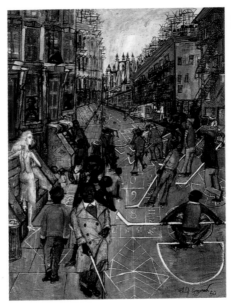

PHILIP EVERGOOD (1901–1973)
Sunny Side of the Street, 1950
Egg-oil varnish emulsion with marble dust and glass on canvas,
50 x 36¼ in. (127 x 92.1 cm)

DAVID PARK (1911–1960)
Sun Bather, 1950–53
Oil on canvas, 36¼ x 46¼ in. (92.1 x 117.5 cm)

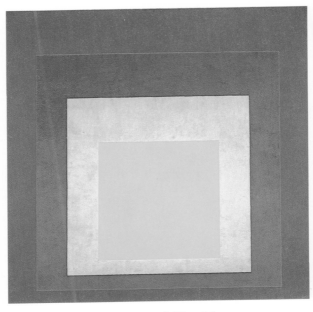

JOSEF ALBERS (1888–1967)
Homage to the Square: "Yes," 1956
Casein on Masonite, 39⅞ x 39⅞ in. (101.3 x 101.3 cm)

HARRY M. CALLAHAN (1912–1999)
Barbara in Florence, Italy, 1957
Dye transfer print, 11 x 14 in. (27.9 x 35.6 cm)

HANS HOFMANN (1880–1966)
Golden Blaze, 1958
Oil on canvas, 72 x 60 in. (182.9 x 152.4 cm)

MARK ROTHKO (1903–1970)
Mulberry and Brown, 1958
Oil on canvas, 66¾ x 61¾ in. (169.6 x 156.9 cm)

HOWARD WILLIAM MEHRING (1931–1978)
Playground, 1958
Acrylic on canvas, 106 x 111 in. (269.2 x 281.9 cm)

HOWARD WILLIAM MEHRING (1931–1978)
Cadmium Groove, 1965
Magna acrylic on canvas, 55 x 48 in. (139.7 x 121.9 cm)

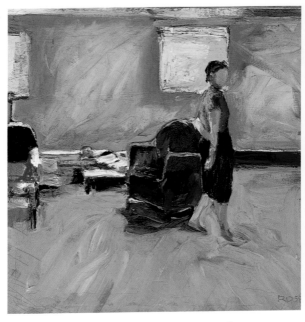

RICHARD DIEBENKORN (1922–1993)
Girl in a Room, 1958
Oil on canvas, 27⅛ x 26 in. (68.9 x 66 cm)

RICHARD DIEBENKORN (1922–1993)
Ocean Park #83, 1975
Oil on canvas, 100½ x 81½ in. (255.3 x 207 cm)

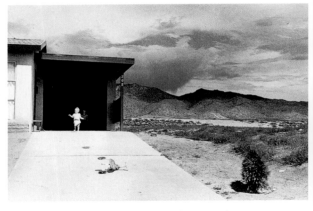

GARRY WINOGRAND (1928–1984)
Albuquerque, New Mexico, 1958
Gelatin silver print, 8⅝ x 12⅞ in. (21.9 x 32.7 cm)

DANNY LYON (b. 1942)
Neshoba County Fair, near Philadelphia, Mississippi, 1964
Gelatin silver print, 13⅜ x 9⅛ in. (34 x 23.2 cm)

GENE DAVIS (1920–1985)
Red Rectangle, 1958
Oil on canvas, 94½ x 114½ in. (240 x 290.8 cm)

GENE DAVIS (1920–1985)
Black Popcorn, 1965
Oil on canvas, 114 x 114 in. (289.6 x 289.6 cm)

MILTON AVERY (1893–1965)
Girl on a High Chair, 1960
Oil on canvas board, 24 x 20 in. (61 x 50.8 cm)

BURGOYNE DILLER (1906–1965)
First Theme, c. 1962
Oil on canvas, 95¾ x 38 in. (243.2 x 96.5 cm)

LOUISE NEVELSON (1900–1988)
Ancient Secrets, 1964
Painted wood, 70⅝ x 62½ x 15 in. (179.4 x 158.8 x 38.1 cm)

ALMA THOMAS (1895–1978)
Pansies in Washington, 1969
Acrylic on canvas, 50 x 48 in. (127 x 121.9 cm)

KENNETH NOLAND (b. 1924)
Brown Stretched, 1966
Acrylic on canvas, 7 x 24 ft. (2.134 x 7.315 m)

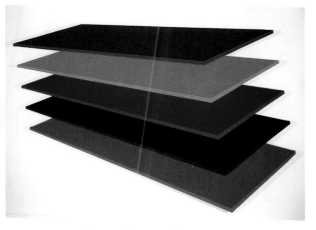

THOMAS DOWNING (1928–1985)
Seven, 1967
Acrylic on canvas, 70 x 96½ in. (177.8 x 245.1 cm)

ROBERT RAUSCHENBERG (b. 1925)
Accident, 1963
Lithograph, 40 x 28½ in. (101.6 x 72.4 cm)

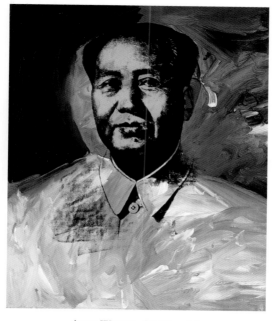

ANDY WARHOL (1928?–1987)
Mao, 1973
Silkscreen and acrylic on canvas, 50¼ x 42 in. (127.6 x 106.6 cm)

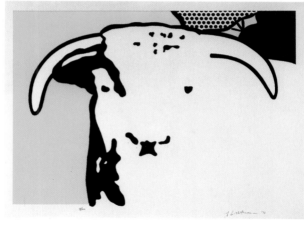

Roy Lichtenstein (1923–1997)
Bull Head I, 1973
Lithograph and linocut, 21⅜ x 29½ in. (54.3 x 74.9 cm)

ROY LICHTENSTEIN (1923–1997)
Bull Head III, 1973
Lithograph, screenprint, and linocut, 21 x 28⅝ in. (53.3 x 72.8 cm)

ELLSWORTH KELLY (b. 1923)
Yellow Red Triangle, 1973
Oil on canvas, 120 x 142 in. (304.8 x 360.7 cm)

AL HELD (b. 1928)
Isabella I, 1974
Graphite on paper, 22½ x 30⅝ in. (57.7 x 77.8 cm)

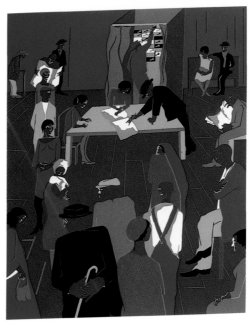

JACOB LAWRENCE (b. 1917)
1920's . . . The Migrants Cast Their Ballots, 1974
Silkscreen, 32 x 24 in. (81.3 x 61 cm)

SAM FRANCIS (1923–1994)
Untitled, 1974
Acrylic on canvas, 99 x 87¼ in. (251.5 x 221.6 cm)

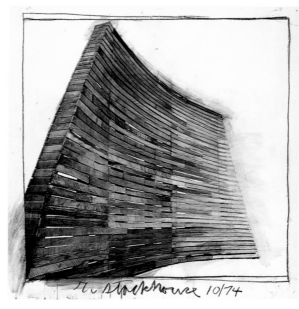

ROBERT STACKHOUSE (b. 1942)
Drawing for "Ghost Dance," 1974
Watercolor, gouache, and charcoal over graphite on paper,
37¾ x 36 in. (95.9 x 91.4 cm)

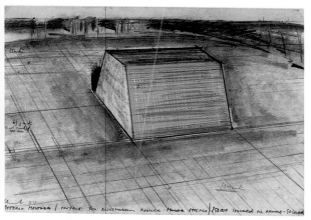

CHRISTO (CHRISTO JAVACHEFF) (b. 1935)
Otterlo Mastaba (Project for Rijksmuseum Kröller-Müller, Otterlo),
1975. Oil pastel, crayon, red ballpoint pen ink, graphite, and
masking tape on paper, 17 x 24⅛ in. (43.2 x 61.3 cm)

ROGER BROWN (b. 1941)
Waterfall, 1974
Oil on canvas, 72 x 48¼ in. (182.9 x 122.6 cm)

FRANK STELLA (b. 1936)
Botafogo II, 1975
Painted aluminum, 84 x 121 in. (213.4 x 307.3 cm)

Peter Milton (b. 1930)
Daylilies, 1975
Etching and engraving, 19½ x 30 in. (49.5 x 76.2 cm)

DAVID LEVINTHAL (b. 1949)
Untitled (Explosion), 1975
Gelatin silver print, 10⅝ x 13½ in. (27 x 34.3 cm)

WILLIAM EGGLESTON (b. 1939)
Memphis, 1975
Dye transfer print, 12 x 17½ in. (30.5 x 44.5 cm)

Ed McGowin (b. 1938)
Untitled, 1975
Colored ink with airbrush and colored pencil over graphite
on paper, 40 x 30 in. (101.6 x 76.2 cm)

JACOB KAINEN (b. 1909)
Blue Dusk, 1980
Color monotype on paper, 24 x 18 in. (61 x 45.7 cm)

KEVIN MACDONALD (b. 1946)
Kitchen Still Life, 1980
Colored pencil and powdered graphite on paper, 22⅜ x 30⅛ in.
(56.8 x 76.5 cm)

ROBERT COLESCOTT (b. 1925)
Auvers-sur-Oise (Crow in the Wheatfield), 1981
Acrylic on canvas, 84 x 72 in. (213.4 x 182.9 cm)

ROBERT FRANK (b. 1924)
Pablo and Sandy, Brattleboro, Vermont (Life Dances On), 1980
Gelatin silver print, 10 x 13⅞ in. (25.4 x 35.2 cm)

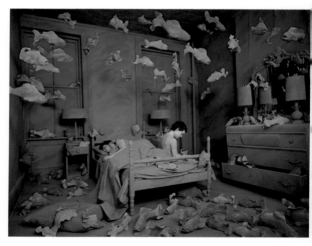

SANDY SKOGLUND (b. 1946)
Revenge of the Goldfish, 1981
Cibachrome print, 28 x 34⅝ in. (71.1 x 87.9 cm)

EVAN SUMMER (b. 1949)
Nocturne IV, 1985
Etching, engraving, and drypoint, 35 x 25 in. (88.9 x 63.5 cm)

ROBERT MANGOLD (b. 1937)
Five Color Frame Painting, 1985
Acrylic on canvas, 94¾ x 78½ in. (240.7 x 199.4 cm)

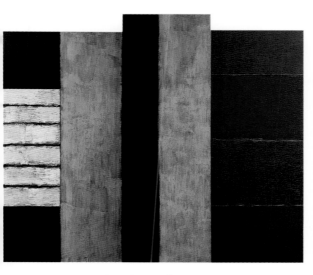

SEAN SCULLY (b. 1945)
Flyer, 1985
Oil on canvas, 102¼ x 119 in. (259.7 x 302.3 cm)

CINDY SHERMAN (b. 1954)
Untitled #168, 1987
Cibachrome print, 84¾ x 59¾ in. (215.3 x 151.8 cm)

LARRY SULTAN (b. 1946)
Evening, Los Angeles, 1987
Chromogenic print, 40¼ x 46⅛ in. (102.2 x 117.2 cm)

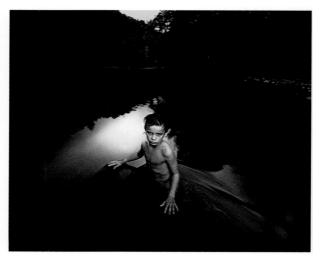

SALLY MANN (b. 1951)
Last Time Emmett Modeled Nude, 1987
Gelatin silver print, 19¾ x 23⅝ in. (50.2 x 60 cm)

JIM GOLDBERG (b. 1953)
Destiny's Shiny Bracelet, 1989
Gelatin silver print, 43⅝ x 33⅜ in. (110.8 x 84.8 cm)

LOUISE BOURGEOIS (b. 1911)
Untitled (with foot), 1989
Pink marble, 30 x 26 x 21 in. (76.2 x 66 x 53.3 cm)

ANDRES SERRANO (b. 1950)
Madonna and Child 2, 1989
Cibachrome print, 40 x 30 in. (101.6 x 76.2 cm)

DAVID BATES (b. 1952)
Cottonmouth, 1988
Oil on canvas, 98 x 80 in. (248.9 x 203.2 cm)

MICHAL ROVNER (b. 1957)
Untitled, from the series Outside, 1990
Chromogenic print, 29½ x 29 in. (74.9 x 73.7 cm)

DONALD LIPSKI (b. 1947)
Black by Popular Demand, 1991
Silk organza, 30 x 30 x 21 ft. (9.144 x 9.144 x 6.401 m)

LORNA SIMPSON (b. 1960)
Coiffure, 1991
3 gelatin silver prints with plastic plaques,
74⅜ x 106 in. (188.9 x 269.2 cm)

LARI PITTMAN (b. 1952)
Reverential and Needy, 1991
Acrylic and enamel on mahogany, 66 x 82 in. (167.6 x 208.3 cm)

IDA APPLEBROOG (b. 1929)
Mother mother I am ill, 1993
Oil on canvas, 110 x 72 x 1¾ in. (279.4 x 182.9 x 4.5 cm)

KIM DINGLE (b. 1951)
Black Girl Dragging White Girl, 1992
Oil and charcoal on canvas, 72 x 60 in. (182.9 x 152.4 cm)

KERRY JAMES MARSHALL (b. 1955)
The Voyager, 1992
Paper, paints, and collage on canvas, 91⅞ x 91¾ in. (233.4 x 233.1 cm)

INDEX OF DONOR CREDITS

INDEX OF ILLUSTRATIONS

PHOTOGRAPHY CREDITS

Ricardo Blanc: 43, 71, 130, 174, 236, 249; Harry Callahan, Courtesy Pace/MacGill Gallery, New York: 221; Chan Chao: 90, 191; Courtesy Paula Cooper Gallery, New York: 267; Copyright © Walker Evans Archive, The Metropolitan Museum of Art: 192; Courtesy Fraenkel Gallery, San Francisco: 228; Peter Harholdt: 17, 20–24, 26, 28, 29, 31, 33, 35, 37, 38, 40, 46–52, 54–59, 62, 63, 65, 67–70, 72–74, 78–84, 87, 89, 90, 92–94, 97, 101–10, 112–15, 119, 122–25, 127–29, 133–35, 137–39, 141–49, 151–56, 158, 164–73, 175–89, 191–208, 211, 215–21, 224–31, 233, 234, 236, 238–41, 243, 244, 246–48, 250, 252, 253, 255, 256, 259, 260, 263–65, 267, 269, 272; Courtesy Sean Kelly Gallery, New York: 271; Jennifer Kotter: 273; Danny Lyon, Courtesy Edwynn Houk Gallery, New York: 229; Edward Owen: 21; Copyright © Philip Pearlstein: 211; Copyright © 2000 Man Ray Trust/Artists Rights Society, NY/ADAGP, Paris: 193; Courtesy of the Artist [Cindy Sherman] and Metro Pictures, New York: 262; Greg Staley: 32, 36, 60, 61, 66, 76, 77, 85, 88, 118, 120, 121, 126, 131, 132, 136, 232, 275

CORCORAN GALLERY OF ART

SELECTION OF WORKS: Philip Brookman, Curator of Photography and Media Arts;
Sarah Cash, Bechhoefer Curator of American Art; Eric Denker, Curator of Prints and
Drawings; Terrie Sultan, Curator of Contemporary Art; Linda Crocker Simmons,
Curator Emeritus

RESEARCH AND EDITORIAL ASSISTANCE: Renée Ater, Assistant Curator of American Art,
with Marisa Keller, Archivist

RIGHTS AND REPRODUCTIONS: Cristina Segovia, Rights and Reproductions Coordinator

With additional thanks to Jack Cowart, the Corcoran's former Deputy Director and
Chief Curator (now Executive Director, Roy Lichtenstein Foundation), and Ellen
Tozer, Director of Retail Operations

ABBEVILLE PRESS
EDITOR: Nancy Grubb
DESIGNER: Paula Winicur and Kevin Callahan
PRODUCTION EDITOR: Kerrie Baldwin
PRODUCTION MANAGER: Louise Kurtz

Library of Congress Cataloging-in-Publication Data
Corcoran Gallery of Art.
 American treasures of the Corcoran Gallery of Art/foreword by David C. Levy;
text by Sarah Cash with Terrie Sultan.
 p. cm.
 "A Tiny folio."
 Includes index.
 ISBN 0-7892-0625-0
 1. Art, American—Catalogs. 2. Art—Washington (D.C.)—Catalogs. 3. Corcoran
Gallery of Art—Catalogs. I. Cash, Sarah. II. Sultan, Terrie, 1952– III. Title.
N6505.C65 2000
709'.73'074753—dc 21 99-046577